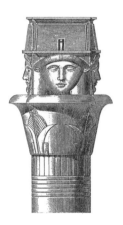

© PCM, Lyon, 2005

ISBN 2-914199-45-7

English: C.-S.-D.
Français : Clara Schmidt
Deutsch: Annett Richter
Español: Stéphanie Lemière
Русский: Любовь Евелева, © Magma, ООО

Egyptian Ornament
Ornement égyptien
Ägyptische Ornamente
Ornamentación egipcia
Египетский Орнамент

Clara Schmidt

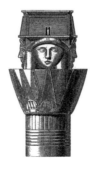

L'Aventurine

Contents • Sommaire • Inhalt • Índice • Оглавление

Foreword

From Ancient Rome to the nineteenth century, the inclination for Egyptian ornaments has come down through the ages. The decorative elements of Egyptian art, which has always been seductive and dreamed of, have been distorted through the ages to satisfy the enthusiasts: Egyptian-style chimneys, pyramid-shaped garden ornaments, temple-shaped clocks, andirons and anthropomorphic armchairs, jewels, fabrics… Obelisks, sphinxes, falcons and monkeys are among the most evocative elements of Egyptian art for Westerners fascinated by exoticism and have appealed to artists, designers and ornamentists, from Renaissance to the nineteenth century, from Piranesi to Percier and Fontaine. A great number of artists were indeed captivated by this art, which draws its inspiration in nature, using various themes like papyrus, birds' feathers, lotuses, palm tree branches…

Architectural ornaments, representation of objects on walls, or purely decorative ornaments, all are highly stylized and polychromatic. An essential element of ornamentation, color is used in flat tints. It emphasizes the stiffness and stylization of the drawings and allows a great number of combinations, even when the ornaments are composed of simple geometrical figures.

This book presents a selection of ornaments taken from Egyptian monuments and temples, as well as Egyptian decorative elements interpreted by Western artists.

Avant-propos

L e goût pour l'ornement égyptien a traversé les siècles, de l'antiquité romaine au XIXᵉ siècle. Les éléments décoratifs de cet art, qui a toujours séduit et fait rêver, ont été détournés au fil du temps pour satisfaire les amateurs : cheminées à l'égyptienne, fabriques en forme de pyramides, pendules-temples, chenets et fauteuils anthropomorphes, bijoux, textiles… Les obélisques, les sphinx, les faucons, les singes figurent parmi les éléments les plus évocateurs pour les Occidentaux passionnés par l'exotisme. Ces éléments ont séduit les artistes, décorateurs et ornemanistes, de la Renaissance au XIXᵉ siècle, de Piranese à Percier et Fontaine. Un grand nombre d'artistes furent en effet fascinés par cet art qui puise son inspiration dans la nature, en utilisant des thèmes comme les papyrus, les plumes d'oiseaux, les lotus, les rameaux de palmiers, les oiseaux, dont une infinité d'ornements dérivent.

Ornements architecturaux, représentations d'objets sur les murs ou ornements purement décoratifs, tous sont hautement stylisés et polychromes. La couleur, élément essentiel de l'ornementation, est utilisée en aplats. Elle accentue la rigidité du dessin et sa stylisation, et permet un grand nombre de combinaisons, même lorsque les ornements ne mettent en jeu qu'un petit nombre de simples figures géométriques.

Ce livre vous présente une sélection de ces ornements, qu'il s'agisse de dessins relevés dans les temples au XIXᵉ siècle ou d'éléments de décor retravaillés par des artistes occidentaux, des dessins géométriques ou figurés, stylisés et toujours élégants.

Vorwort

Seit der römischen Antike bis ins 19te Jahrhundert hat sich das Interesse an ägyptischen Ornamenten gehalten. Ihre künstlerischen Motive, die schon immer verzaubert und zum Träumen verleitet haben, fanden im Laufe der Zeit immer wieder neue Liebhaber und Anwendungen, ägyptische Kamine in Pyramidenform, tempelförmige Standuhren, antrompomorphe Feuerstellen und Sessel, Schmuck und Textilien. Obelisken, Sphinx, Falken und Affen sind die beliebtesten Elemente, die die ägyptische Kunst und überhaupt alles Exotische bewundernden Europäer faszinieren. Sie haben Künstler und Dekorateure von der Renaissance bis ins 19te Jahrhundert in ihren Bann geschlagen, von Piranesi bis Percier oder Fontaine. Eine Vielzahl von Künstlern war von dieser Kunst fasziniert, die ihre Inspirationen aus der Natur schöpft.

Sie verwendet Motive wie Papyri, Vogelfedern, Lotus, Palmenzweige und Vögel. Unzählige Ornamente sind daraus entstanden. Architektonische Ornamente, Gegenstände auf Mauern oder einfach nur rein dekorative Ornamente sind hoch stilisiert und vielfarbig dargestellt. Die Farbe als wesentliches Stilelement wird nur vollflächig angewandt. Sie unterstreicht die Starre der Zeichnung und Stile, erlaubt aber eine große Vielfalt von Kombinationen, selbst wenn die Zahl der geometrischen Figuren sehr eingeschränkt ist.

Dieser Band zeigt eine Auswahl dieser Ornamente, seien es Zeichnungen des 19ten Jahrhunderts aus alten Tempeln oder von westlichen Künstlern bearbeitete dekorative Elemente, geometrische oder figurative Zeichnungen. Immer sind sie stilisiert und elegant.

Prólogo

El gusto por el ornamento egipcio ha atravesado los siglos, desde la antigüedad romana hasta el siglo XIX. Los elementos decorativos de este arte, que siempre ha seducido y hecho soñar, han sido adaptados con el paso del tiempo para satisfacer a los aficionados: chimeneas a la egipcia, fábricas en forma de pirámide, péndulos-templos, morillos y sillones antropomorfos, joyas, textiles... Obeliscos, esfinges, halcones y simios figuran entre los elementos más evocadores para los Occidentales apasionados por el exotismo. Estos elementos han seducido a los artistas, decoradores y ornamentistas, desde el Renacimiento hasta el siglo XIX, de Piranese a Percier y Fontaine. Numerosos artistas fueron fascinados por este arte que toma su inspiración de la naturaleza, utilizando temas como los papiros, las plumas de pájaros, los lotos, las ramas de palmeras o los pájaros, de los cuales derivan una infinidad de ornamentos.

Ornamentos arquitecturales, representaciones de objetos sobre las paredes u ornamentos puramente decorativos, todos son muy estilizados y policromos. El color, elemento esencial de la ornamentación, es utilizado en planicidad. Acentua la rigidez del dibujo y su estilización, y permite un gran número de combinaciones, aun cuando los ornamentos cuentan con pocas figuras geométricas simples.

Este libro le presenta una selección de estos ornamentos, tanto de dibujos recogidos en los templos en el siglo XIX como de elementos de adorno retocados por artistas occidentales, dibujos geométricos o figurados, estilizados y siempre elegantes.

Предисловие

Со времен Древнего Рима и на протяжении всего 19-го столетия было распространено увлечение египетским орнаментом. Декоративные элементы египетского искусства всегда притягивали художников и волновали их творческое воображение, но на протяжении веков декоративные орнаменты претерпели изменения, приспосабливаясь к вкусам восторженных почитателей. В египетском стиле выполнялись камины, садовые орнаменты повторяли формы пирамид, мотивы египетских храмов копировались при изготовлении часов, подставок для каминов и кресел, изделий из драгоценных камней и тканей. Для ценителей искусства стран Запада наибольший интерес представляли такие элементы египетского искусства, как обелиски, сфинксы, соколы и обезьяны, пленявшие своей экзотикой мастеров, занимавшихся росписью и украшением интерьеров и созданием орнаментов, начиная с эпохи Ренессанса и на протяжении 19-го столетия, от Пиранези до Персье и Фонтена. Очень многие художники были поистине увлечены египетским искусством, которое черпало вдохновение в природе, используя различные мотивы, например, папирус, перья птиц, цветок лотоса, пальмовые ветви.

Все архитектурные орнаменты для настенной росписи и чисто декоративные орнаменты отличаются высокой степенью стилизации и полихромии. Будучи важнейшим элементом орнаментики, цвет используется для гармонизации оттенков. Он подчеркивает строгость и стилизацию рисунков и позволяет использовать их в самых различных сочетаниях, даже в тех случаях, когда орнаменты составлены из простых геометрических фигур.В данной книге представлены различные виды орнаментов, характерные для египетских памятников и культовых сооружений, а также декоративные элементы египетского искусства в интерпретации западных художников.

Flowers
Fleurs
Blumen
Flores
Цветы

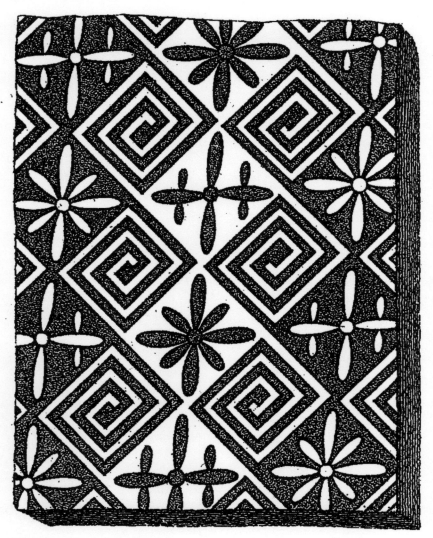

Mural pattern. Bani Hasan.
Motif mural. Bani Hasan.
Wandmalerei. Bani Hasan.
Motivo mural. Bani Hasan.
Настенный орнамент. Бани Хасан.

Description de l'Égypte, Paris, 1809.

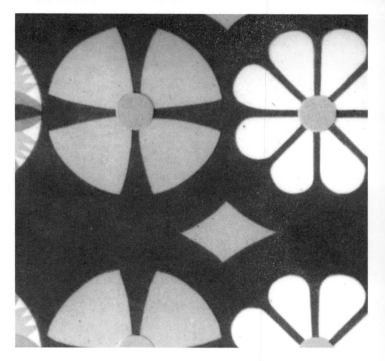

Tomb Murals. **Top and bottom:** Thebes. **Center:** Tell el Amarna.

Peintures murales de tombes. **Haut et bas:** Thèbes. **Centre:** Tell el Amarna.

Grabfresken. **Oben und unten:** Thebes. **Mitte:** Tell el Amarna.

Pinturas murales de sepulcros. **Arriba y abajo:** Thèbes. **Centro:** Tell el Amarna.

Настенные росписи гробницы. Наверху и внизу: Фивы. В центре: Тель Эль Амарна.

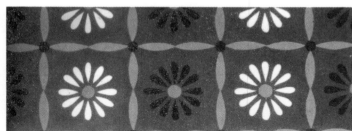

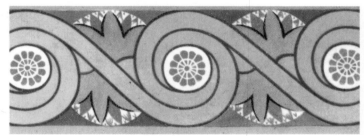

17

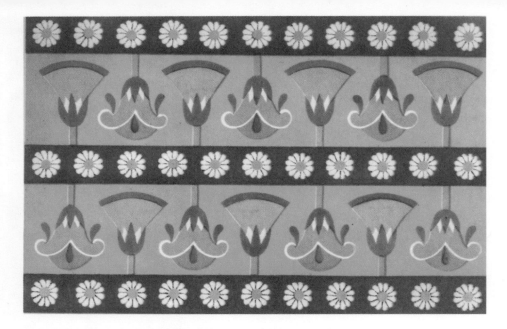

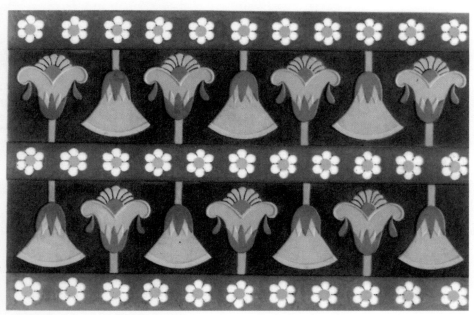

18

18:

Tomb murals. **Top:** Saqqara.
Bottom: Thebes.

Peintures murales de tombes.
Haut: Saqqara. **Bas:** Thèbes.

Grabfresken. **Oben:** Saqqara.
Unten: Thebes.

Pinturas murales de sepulcros.
Arriba: Saqqara. **Abajo:** Tebas.

Настенные росписи гробницы.
Наверху: Саккара.
Внизу: Фивы.

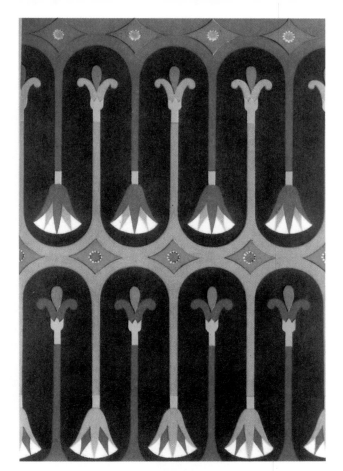

19:

Top: Tomb murals. Thebes.
Bottom: Murals from the temple of
Amenophis III. Karnak.

Haut: Peintures murales de
tombes. Thèbes. **Bas:** Peintures
murales relevées dans le temple
d'Aménophis III. Karnak.

Oben: Grabfresken. Thebes.
Unten: Wandgemälde im Tempel
von Amenophis III. Karnak.

Arriba: Pinturas murales de
sepulcros. Tebas. **Abajo:** Pinturas
murales del templo de
Amenophis III. Karnak.

Наверху: Настенные росписи
гробницы. Фивы. Внизу:
Фрески из храма Аменотепа III.
Карнак.

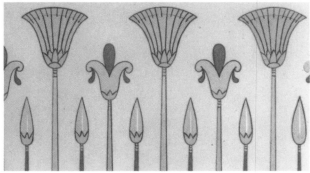

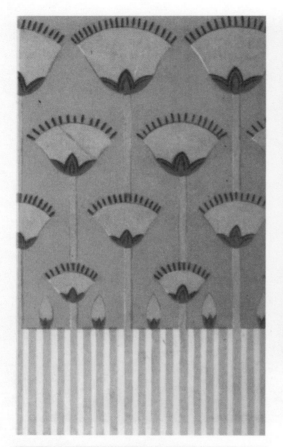

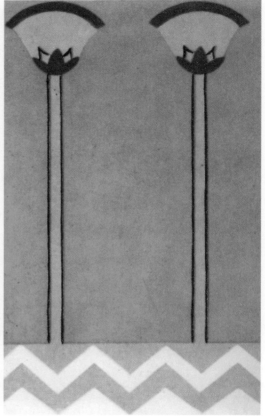

Tomb murals. Thebes.
Peintures murales de tombes. Thèbes.
Grabfresken. Thebes.
Pinturas murales de sepulcros. Tebas.
Настенные росписи гробницы. Фивы.

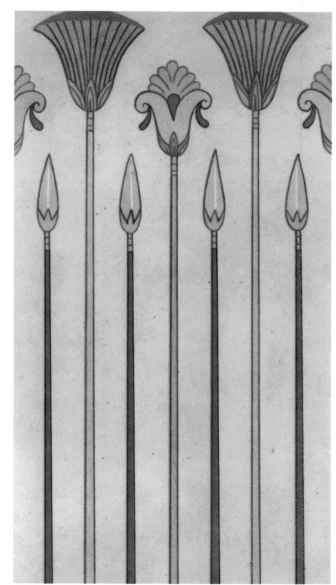

Mural from the temple of Amenophis III. Karnak.

Peinture murale relevée dans le temple d'Aménophis III. Karnak.

Wandgemälde im Tempel von Amenophis III. Karnak.

Pinturas murales del templo de Amenophis III. Karnak.

Фреска из храма Аменотепа III. Карнак.

22:
Tomb murals. Thebes.
Peintures murales de tombes. Thèbes.
Grabfresken. Thebes.
Pinturas murales de sepulcros. Tebas.
Настенные росписи гробницы. Фивы.

23:
Coffins' tops.
Couvercles de cercueils.
Sargdeckel.
Tapas de ataudes.
Росписи крышек гробов.

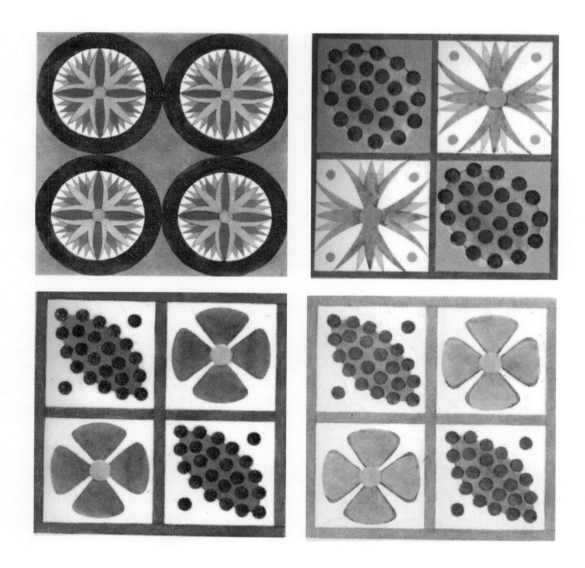

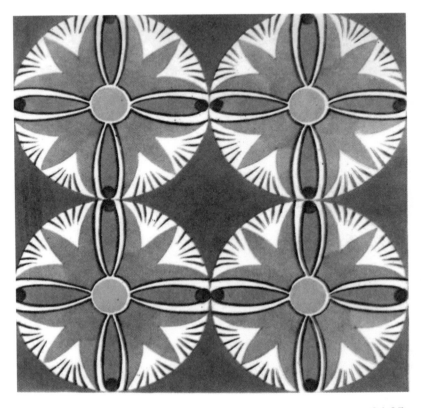

24-25:
Tomb murals. Thebes.
Peintures murales de tombes. Thèbes.
Grabfresken. Thebes.
Pinturas murales de sepulcros. Tebas.
Росписи гробниц. **Фивы.**

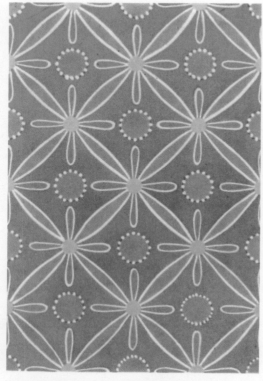

Tomb murals. Thebes.
Peintures murales de tombes. Thèbes.
Grabfresken. Thebes.
Pinturas murales de sepulcros. Tebas.
Настенные росписи гробницы. Фивы.

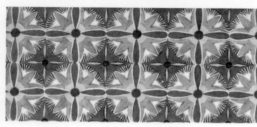

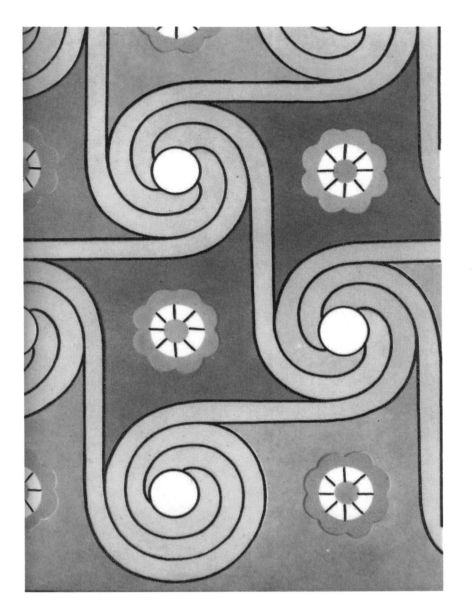

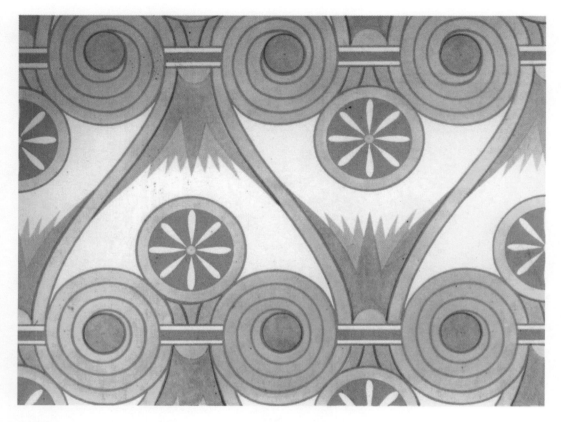

30-35:
Tomb murals. **Top:** Saqqara. **Bottom:** Thebes.
Peintures murales de tombes. **Haut:** Saqqara. **Bas :** Thèbes.
Grabfresken. **Oben:** Saqqara. **Unten:** Thebes.
Pinturas murales de sepucros. **Arriba:** Saqqara. **Abajo:** Tebas.
Настенные росписи гробницы. Наверху: Саккара. Внизу: Фивы.

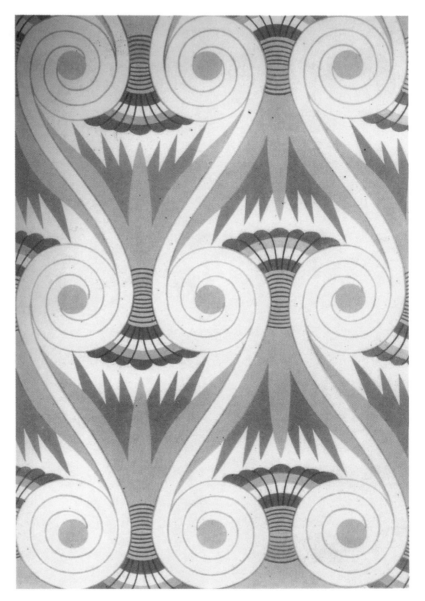

31

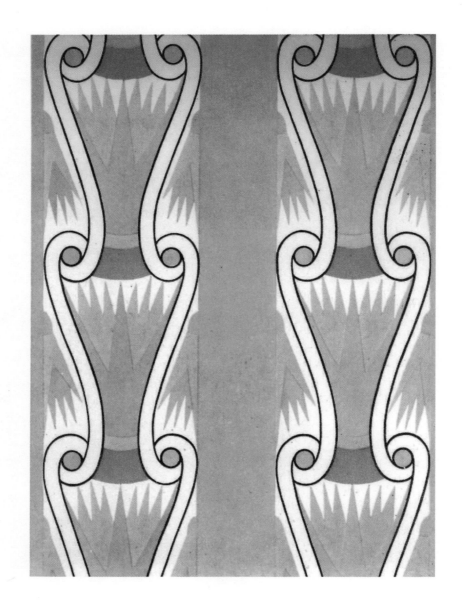

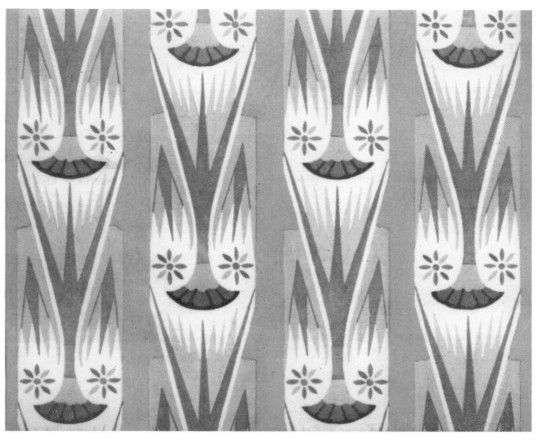

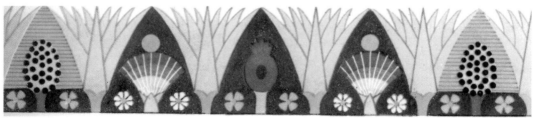

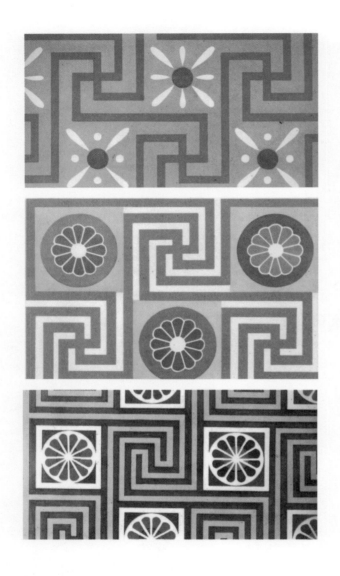

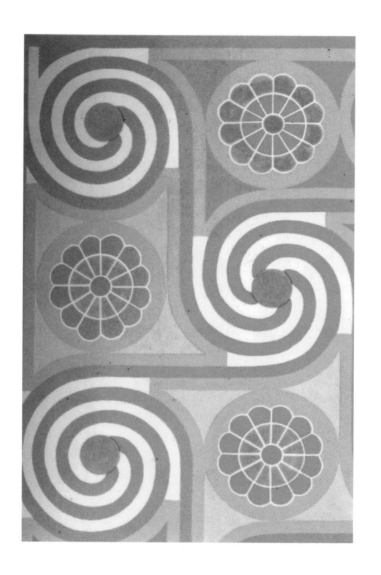

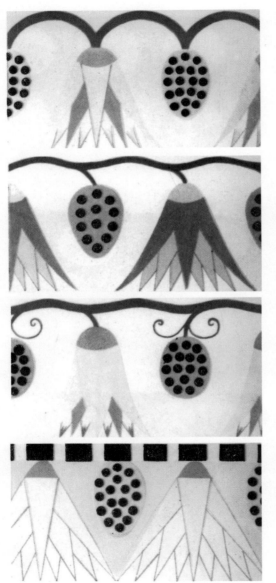

36:

Tomb murals. **Top and centre:** Thebes. **Bottom:** Saqqara.

Peintures murales de tombes. **En haut et au centre:** Thèbes. **En bas:** Saqqara.

Grabfresken. **Oben und mitte:** Thebes. **Unten:** Saqqara.

Pinturas murales de sepulcros. **Arriba y en el centro:** Tebas. **Abajo:** Saqqara.

Настенные росписи гробницы. Наверху и в центре: Фивы. Внизу: Саккара.

37-48:

Tomb murals. Thebes.

Peintures murales de tombes. Thèbes.

Grabfresken. Thebes.

Pinturas murales de sepulcros. Tebas.

Настенные росписи гробницы. Фивы.

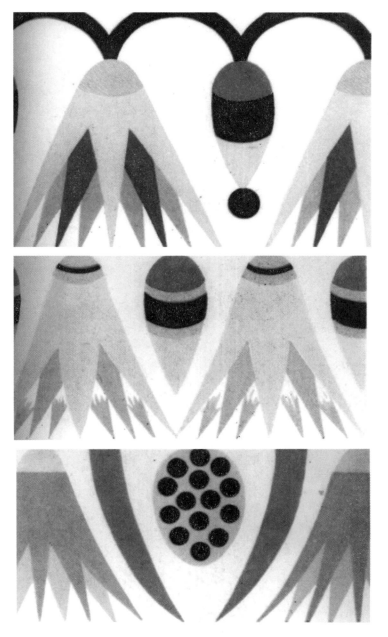

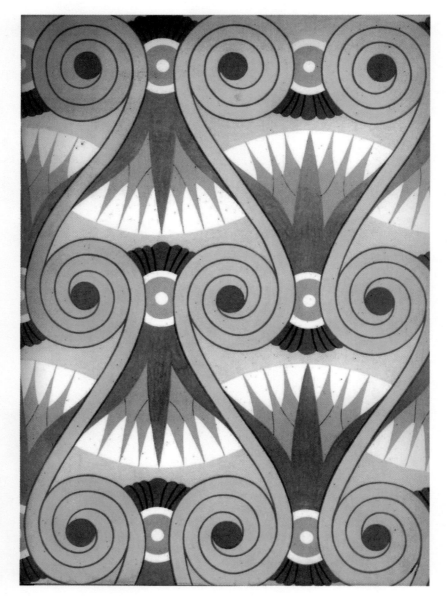

38

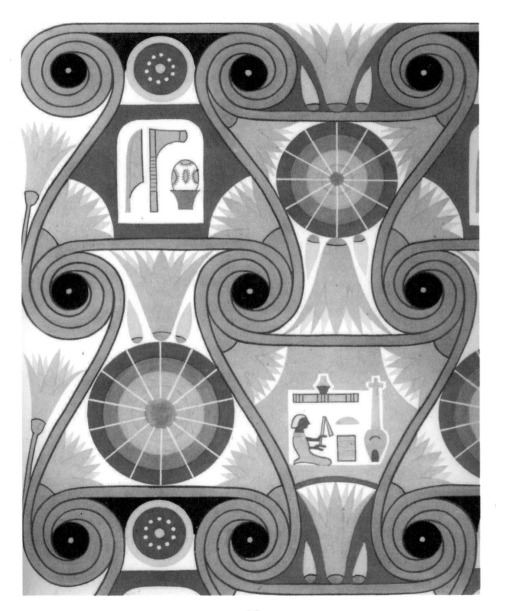

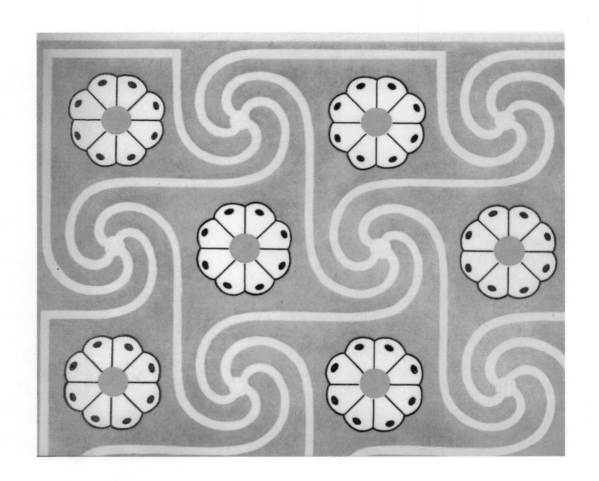

40

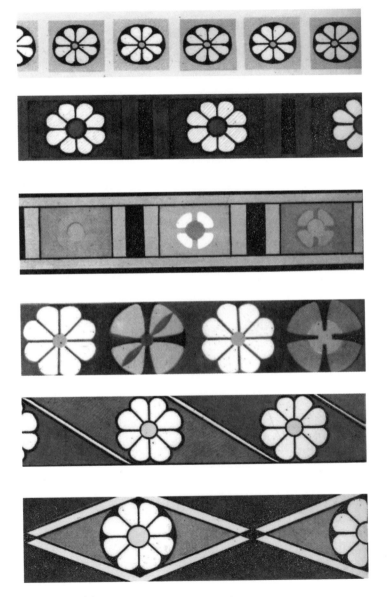

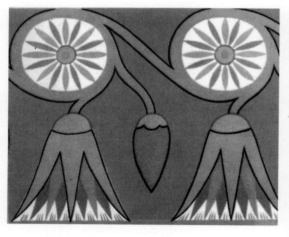
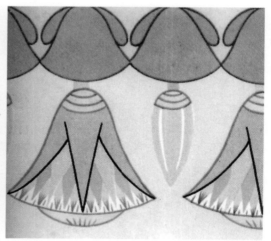
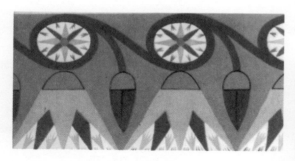

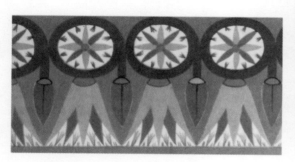

44

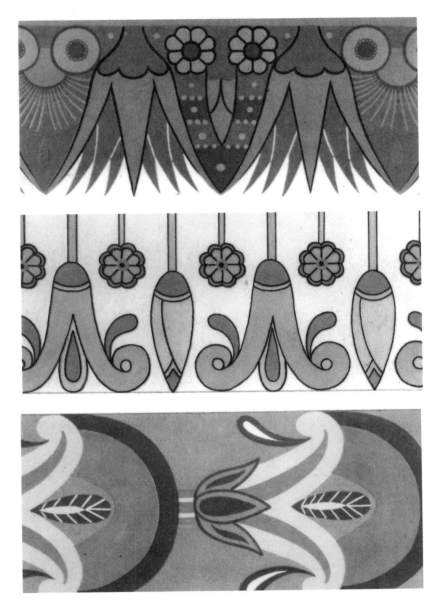

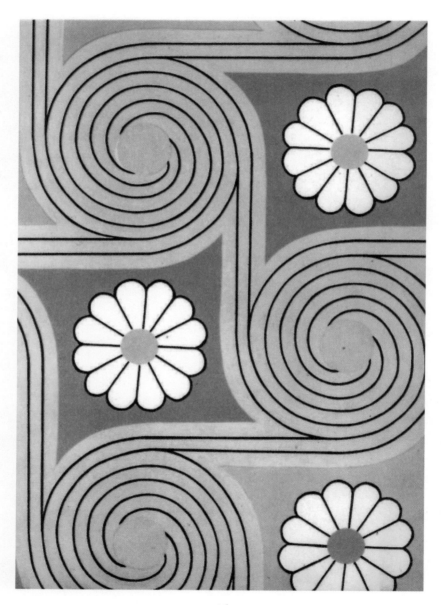

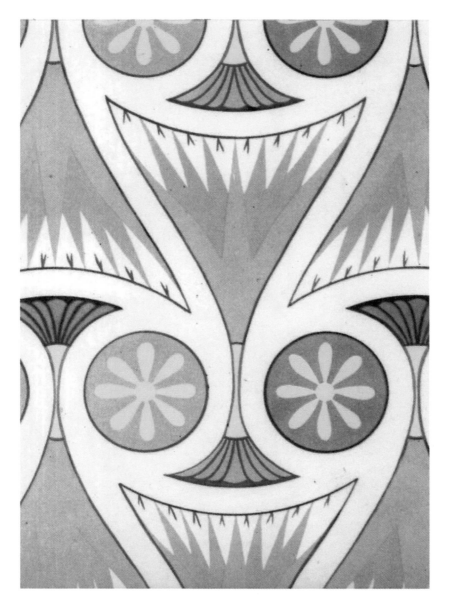

47

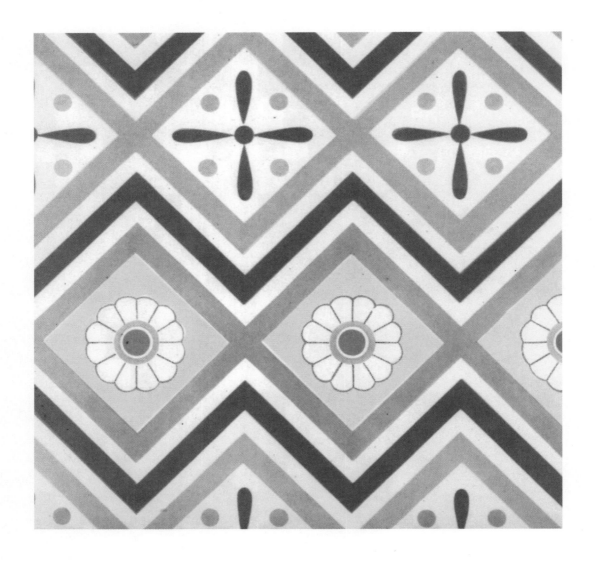

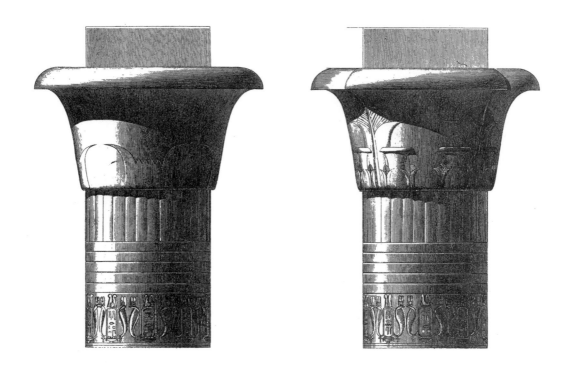

49-50: Temple dedicated to Soukhos and Haroeris: vegetal capitals. Kum Umbu.
Temple dédié à Soukhos et Haroéris : chapiteaux végétaux. Kûm Umbu.
Sukos und Haroris Tempel: pflanzliche Kapitelle. Kum Umbu.
Templo dedicado a Soukhos y Haroeris: capiteles vegetales. Kum Umbu.
TemХрам в честь Сухоса и Гора-старшего. Капители с растительным
орнаментом. Кум Умбу.

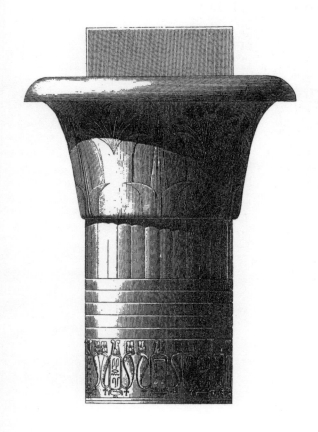 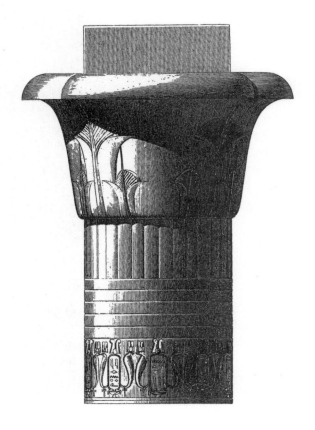

50

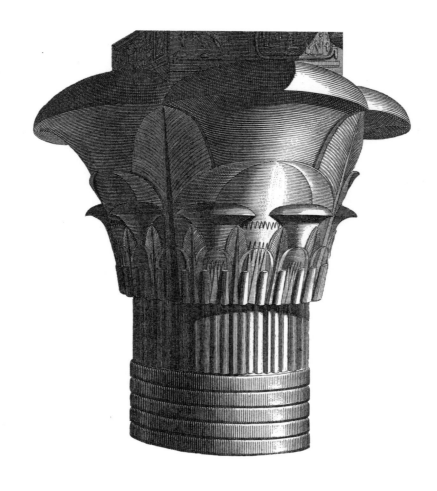

Horus temple, hypostyle room: vegetal capital. Edfu.
Temple d'Horus, salle hypostyle : chapiteau végétal. Edfu.
Tempel von Horus: pflanzliche Kapitelle. Edfu.
Templo de Horus, sala hipóstila: capitel vegetal. Edfu.
Храм Гора, гипостильный зал. Капители с растительным орнаментом. Эдфу.

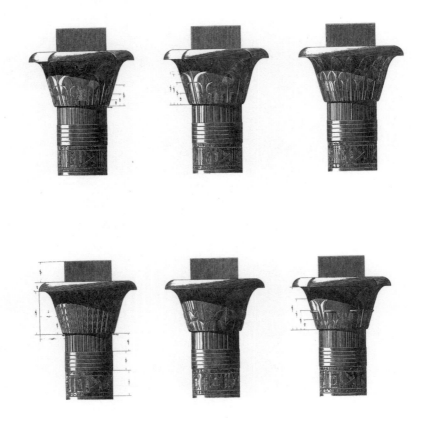

Khnoum temple, hypostyle room: vegetal capitals. Esne.
Temple de Khnoum, salle hypostyle : chapiteaux végétaux. Esné.
Tempel von Khnum, Säulensaal: pflanzliche Kapitelle. Esne.
Templo de Khnoum, sala hipóstila: capiteles vegetales. Esne.
Храм Хнума, гипостильный зал. Капители с растительным орнаментом. Эсне.

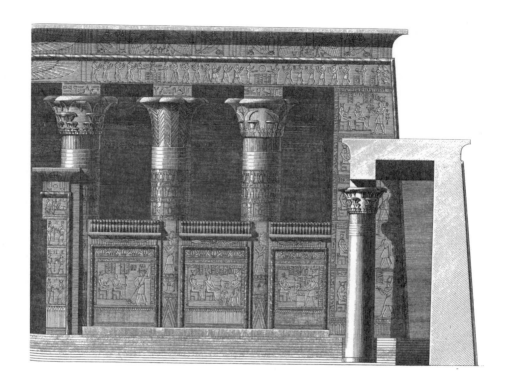

Horus temple: first courtyard portico. Edfu.
Temple d'Horus : portique de la première cour. Edfu.
Tempel von Horus: Säulengang im ersten Hof. Edfu.
Templo de Horus: pórtico de la primera corte. Edfu.
Храм Гора, первый внутренний портик. Эдфу.

53

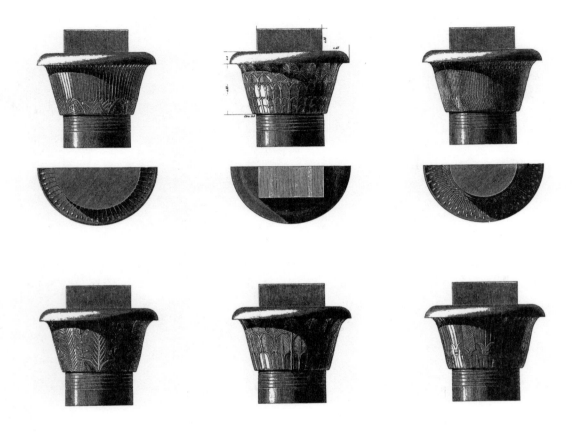

Nebet temple: capitals elevation and section. Esne.
Temple de Nebet : élévation et section de chapiteaux. Esné.
Tempel von Nebet: Kapitelle, Standriss und Profil. Esne.
Templo de Nebet: levantamiento y sección de capiteles.
Храм Небет. Вид капителей спереди и поперечное сечение. Эсне.

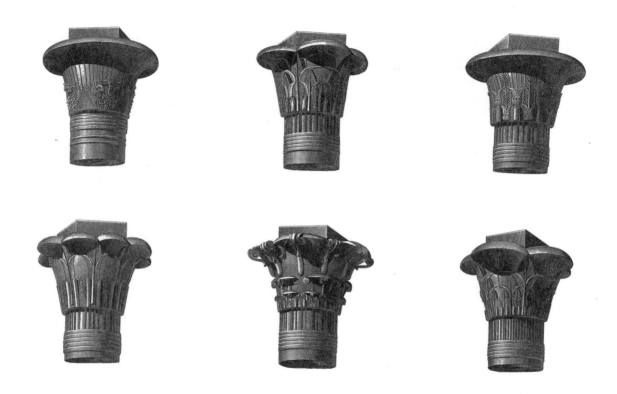

Khnoum temple, hypostyle room: vegetal capitals. Esne.
Temple de Khnoum, salle hypostyle : chapiteaux végétaux. Esné.
Tempel von Khnum, Säulensaal: pflanzliche Kapitelle. Esne.
Templo de Khnoum, sala hipóstila: capiteles vegetales, Esne.
Храм Хнума, гипостильный зал. Капители с растительным орнаментом. Эсне.

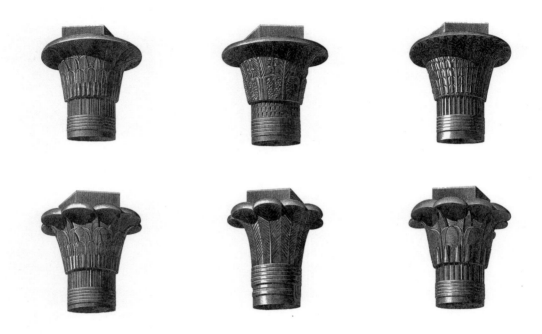

Khnoum temple, hypostyle room: vegetal capitals. Esne.
Temple de Khnoum, salle hypostyle : chapiteaux végétaux. Esné.
Tempel von Khnum, Säulensaal: pflanzliche Kapitelle. Esne.
Templo de Khnoum, sala hipóstila, capiteles vegetales. Esne.
Храм Хнума, гипостильный зал. Капители с растительным орнаментом. Эсне.

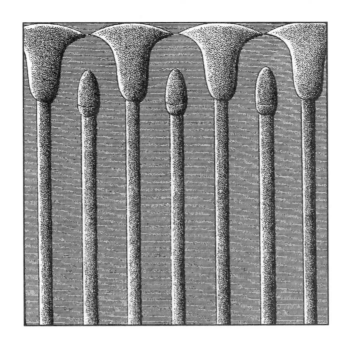

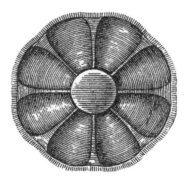

Bas-reliefs details. Thebes and Quft.
Bas-reliefs, détails. Thèbes et Quft.
Flach erhabene Arbeit, Einzelheiten. Thebes und Quft.
Bajo relieve, detalles. Tebas y Quft.
Детали барельефов. Феб и Коптос.

Min temple: foliated pattern. Quft
Temple de Min : rinceau. Quft.
Tempel von Min: Rankenornament. Quft
Templo de Min: follaje. Quft.
Храм Мина. Лиственный орнамент. Коптос.

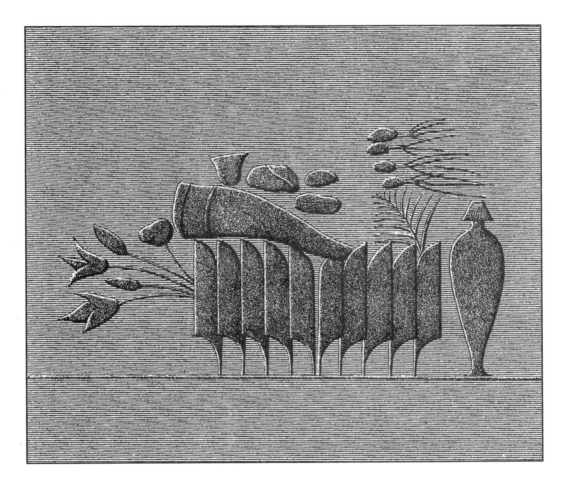

Bas-relief. Bani Hasan necropolis.
Bas-relief. Nécropole de Bani Hasan.
Flach erhabene Arbeit. Nekropole von Bani Hasan.
Bajo relieve. Necrópolis de Bani Hasan.
Барельеф. Некрополь Бани Хасана.

Nebet temple : bas-relief. Esne.
Temple de Nebet : bas-relief. Esné.
Tempel von Nebet: Flach erhabene Arbeit. Esne.
Templo de Nebet: bajo relieve. Esne.
Храм Небет. Барельеф. Эсне.

Khnoum temple: ornamentation of a column base. Esne.
Temple de Khnoum : décor de la base d'une colonne. Esné.
Temple von Khnum: Ornamente an einem Säulenfuss. Esne.
Templo de Khnoum: decorado de la basa de una columna. Esne.
Храм Хнума, орнамент на основании колонны. Эсне.

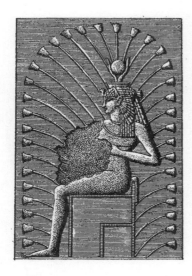

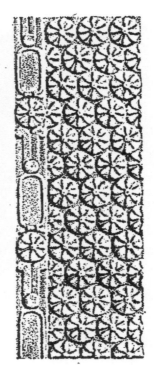

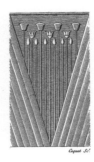

Bas-relief and details. Edfu and Armant. Khnoum temple, hypostyle room: ornamentations of a column base. Esne.

Bas-relief et détails. Edfu et Armant. Temple de Khnoum, salle hypostyle : décors d'une base de colonne. Esné.

Flach erhabene Arbeit und Einzelheiten. Edfu und Armant. Tempel von Khnum , Säulensaal: Ornemente an einem Säulenuss. Esne.

Bajo relieve y detalles. Edfu y Armant. Templo de Khnoum, sala hipóstila: decorado de la basa de una columna. Esne.

Барельеф и детали. Эдфу и Армант.

Храм Хнума, гипостильный зал.

Орнамент на основании колонны. Эсне.

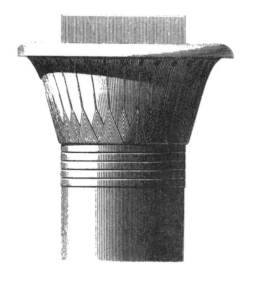

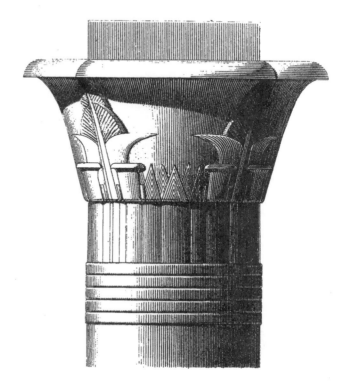

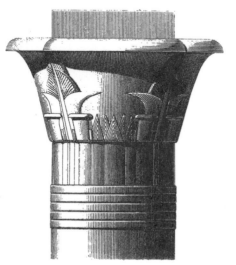

63-64:

Description de l'Égypte,
Paris, 1809.

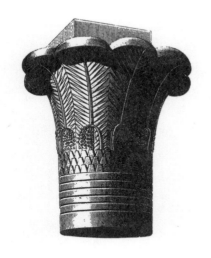

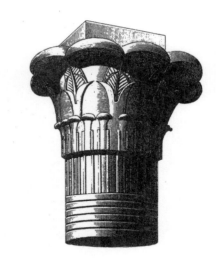

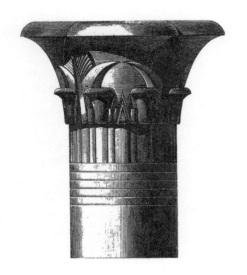

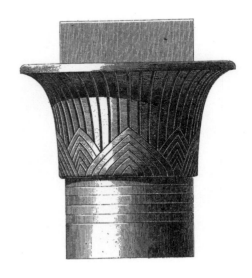

Figures
Figuren
Personajes
Персонажи

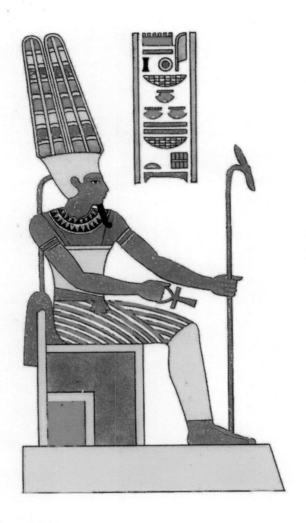

66:
Amon.
Амон.

67:
Ptah.
Птах.

Champollion, *Panthéon
égyptien,* Paris, 1823.

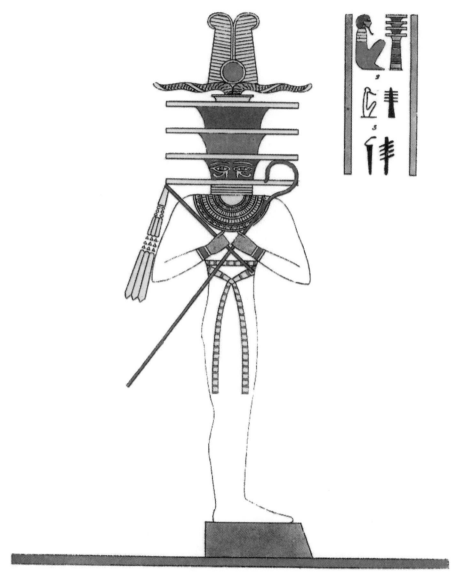

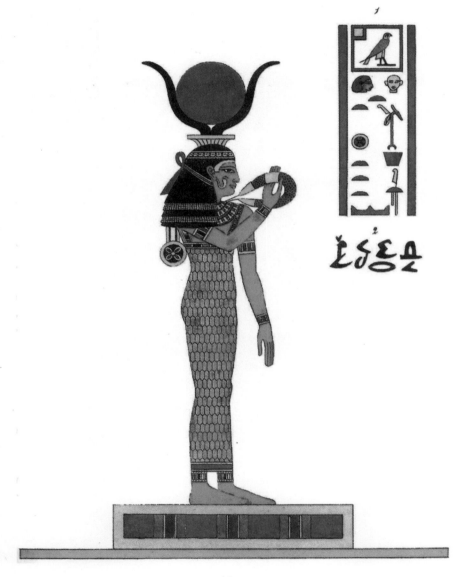

68

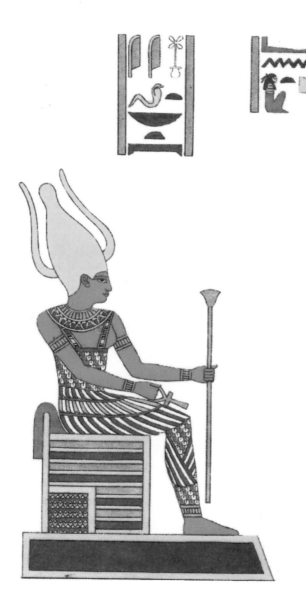

68: Athor.
Атор.

69: Anouke.
Анук.

70: Tpe.
Тпе.

71: Thoth and a
Horapollon priest.
Thoth et un prêtre
d'Horapollon.
Thoth und ein priester
von Horapollon.
Thoth y uno sacerdote
de Horapollon.
Тот и жрец
Гораполлон.

Champollion, *Panthéon
égyptien,* Paris, 1823.

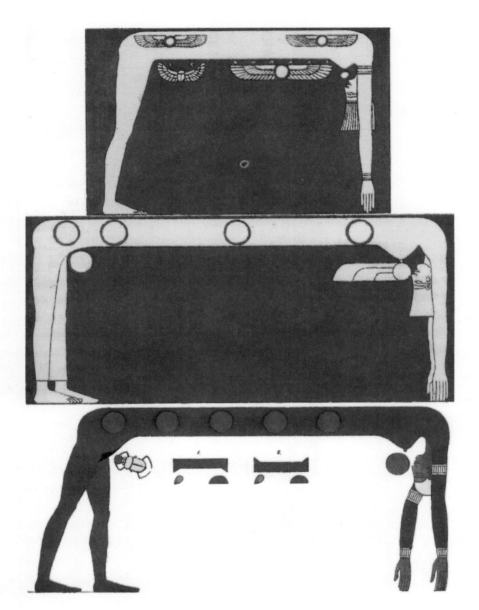

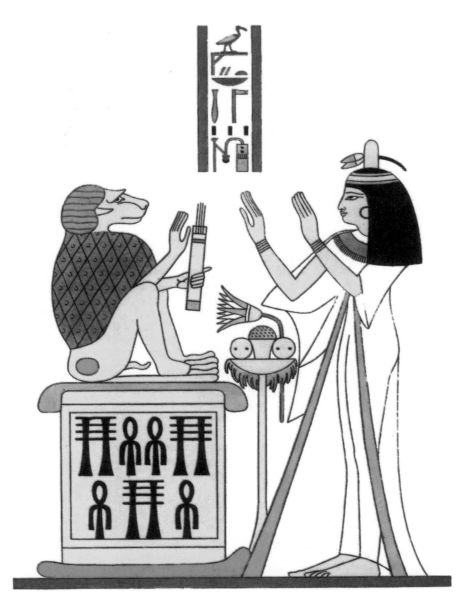

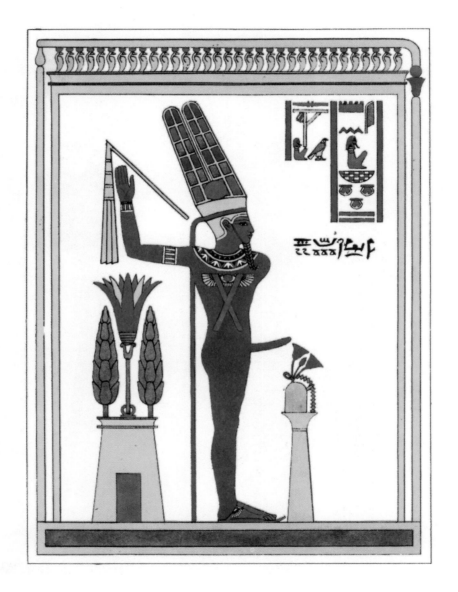

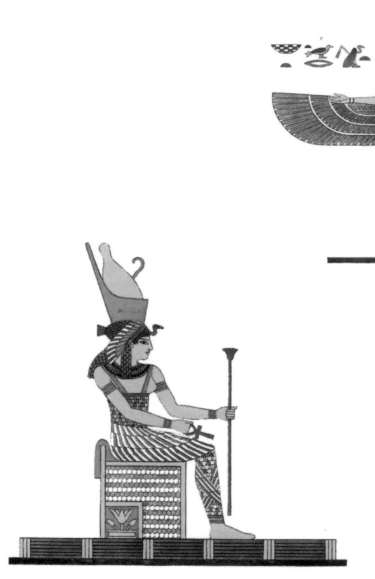

72: Amon.
Амон.

73: Neith.
Нейт.

74: Sate.
Сате.

75: Phtah-Sokari.
Птах-Сокар.

Champollion, *Panthéon égyptien,*
Paris, 1823.

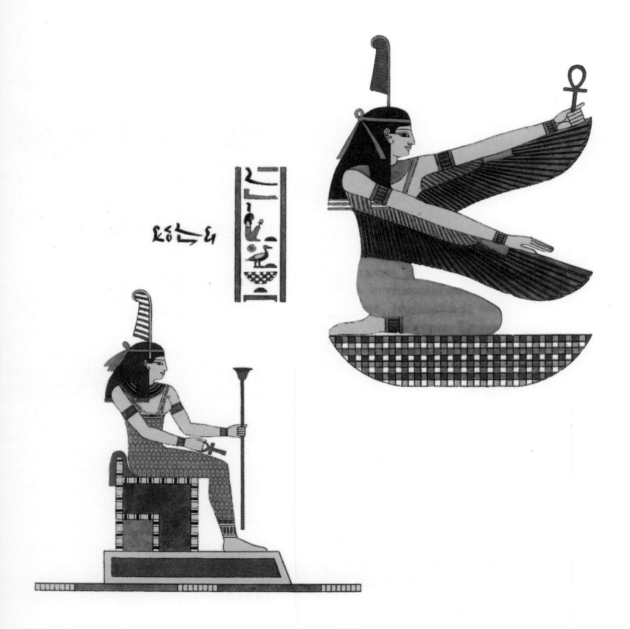

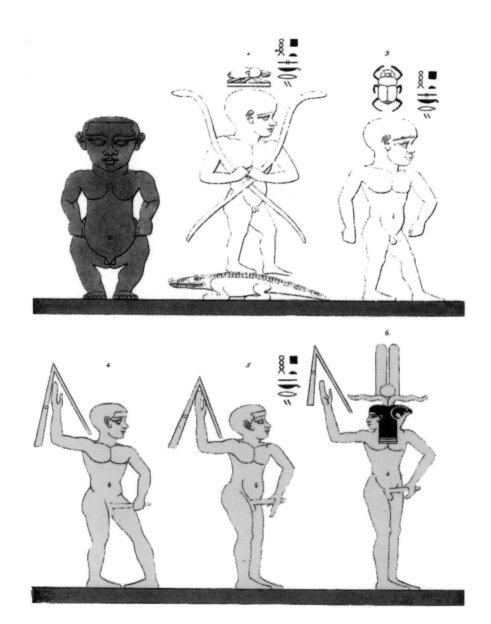

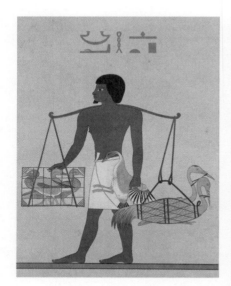

76: Return from hunting. **Left:** Beni-Hasan. **Right:** Thebes.

Retour de chasse. **Gauche:** Beni-Hasan. **Droite:** Thèbes.

Rückkerhr von der Jagd. **Links:** Beni-Hasan. **Rechts:** Thebes.

De regreso de la caza. **Izquierda:** Beni-Hasan. **Derecha:** Tebas.

Возвращение с охоты. Слева: Бани Хасан. Справа: Фивы.

Prisse d'Avennes, *L'Art égyptien*, Paris, 1879.

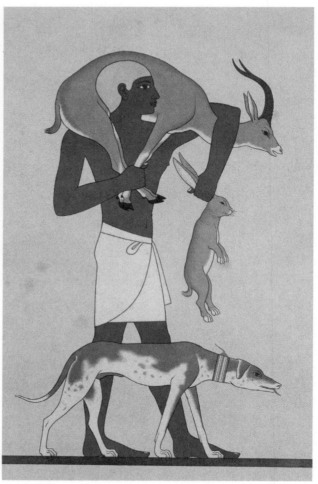

77: Anouke and Ramses II. Talmis.

Anouké et Ramses II. Talmis.

Анук и Рамзес II. Талмис.

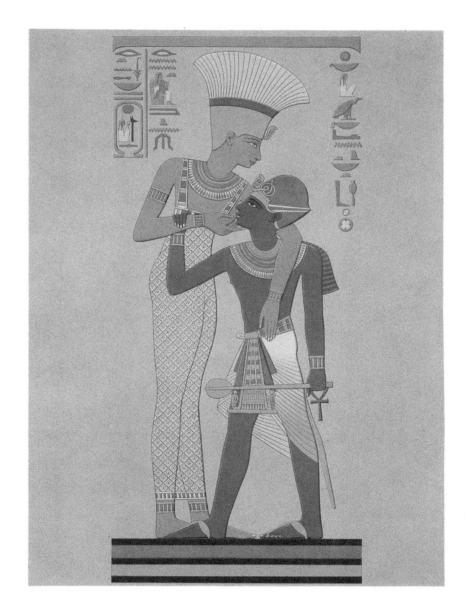

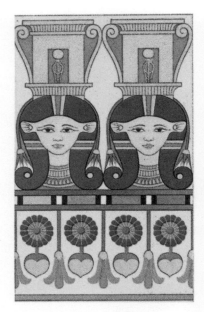

78: Left: Isis. **Right:** Pharaoh
Mienptah-Hotephimat. Thebes.
Gauche: Isis. **Droite:** Le pharaon
Mienptah-Hotephimat. Thèbes.
Links: Isis. **Rechts:** Pharao
Mienptah-Hotephimat. Thebes.
Izquierda: Isis. **Derecha:** El faraón
Mienptah-Hotephimat. Tebas.
Слева: Исида. Справа: фараон.
Мьенптах-Хотефимат. Фивы.

Prisse d'Avennes, *L'Art égyptien*,
Paris, 1879.

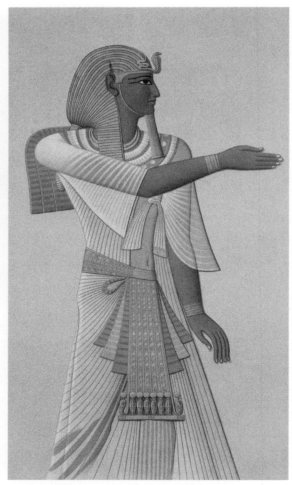

79: Columns and pillars.
Colonnes et piliers.
Säulen und Pfeiler.
Колонны и опоры.

78

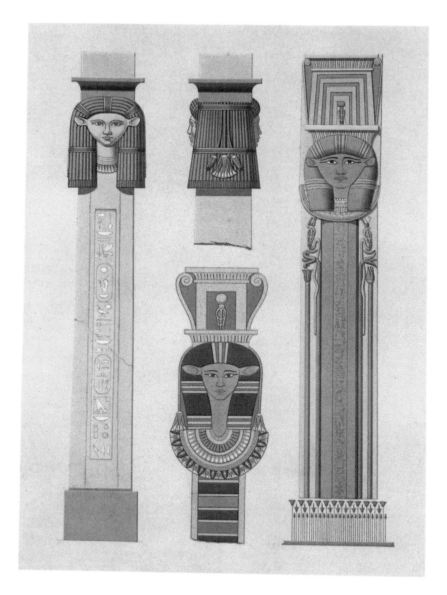

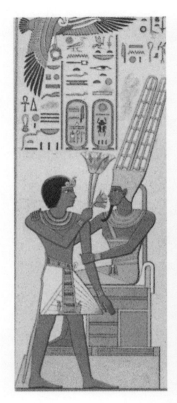

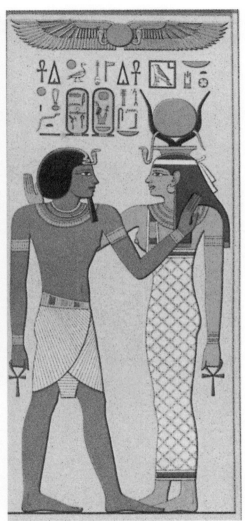

Pillars. Details.
Piliers. Détails.
Pfeiler. Einzelheiten.
Pilares. Detalles.
Декоративная
роспись колонн,
фрагменты.

Prisse d'Avennes, *L'Art*
égyptien, Paris, 1879.

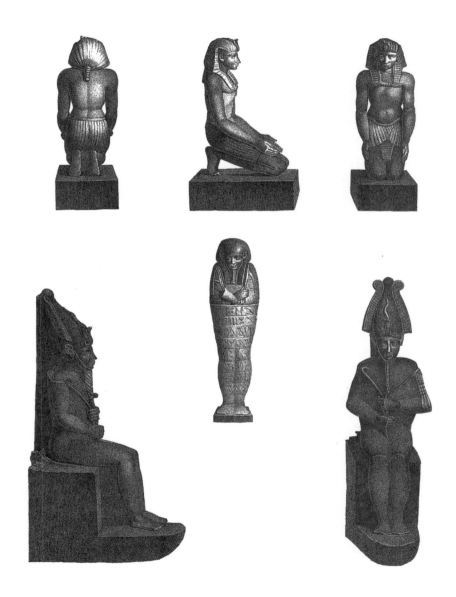

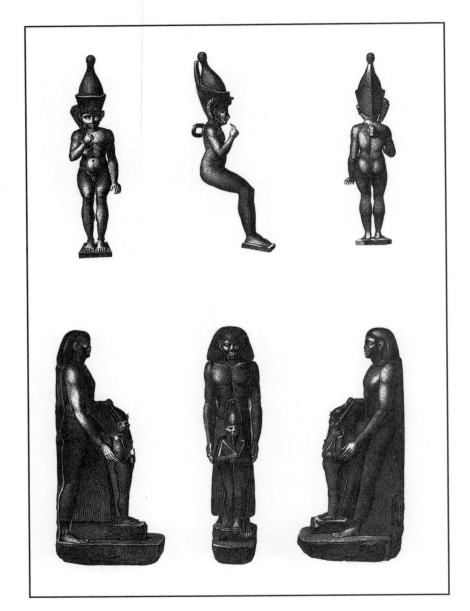

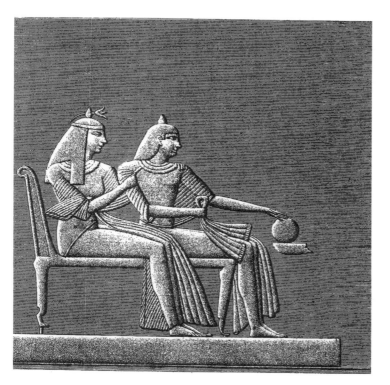

84:
Bronze and serpentine figures.
Figures en bronze et en serpentine.
Figuren in Bronze und Serpentin.
Estatuitas de bronce y de serpentina.
Фигуры из бронзы и серпентина.

85-86:
Bas-reliefs. Elethyia.
Flach erhabene Arbeit. Elethyia.
Bajo relieve. Elethyia.
Барельефы. Элетия.

Description de l'Égypte,
Paris, 1809.

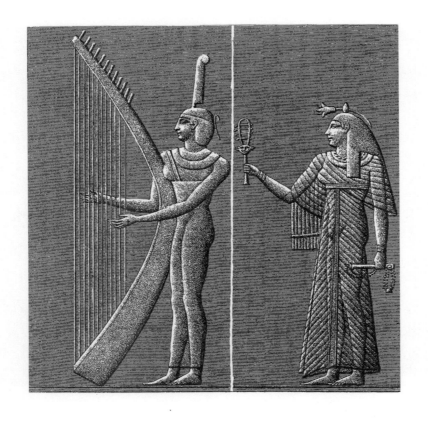

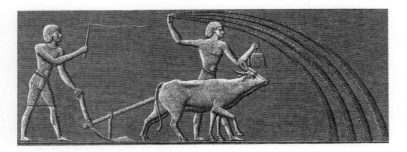

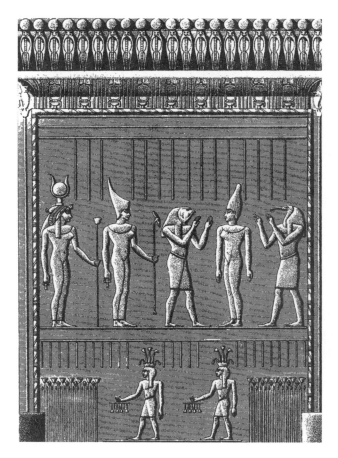

87-92:
Bas-reliefs. Esne.
Bas-reliefs. Esné.
Flach erhabene Arbeit.
Esne.

Bajos relieves. Esne.
Барельефы, Эсне.

Description de l'Égypte,
Paris, 1809.

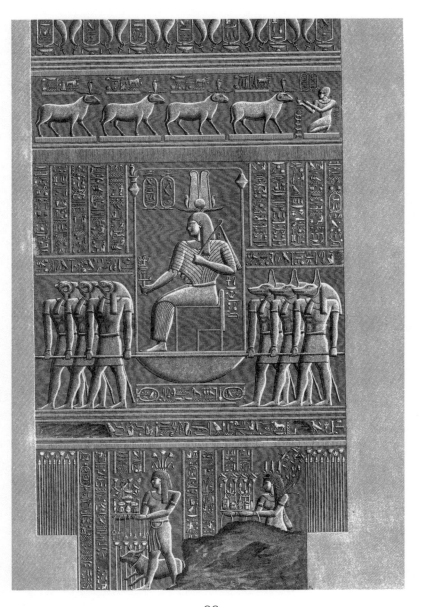

88

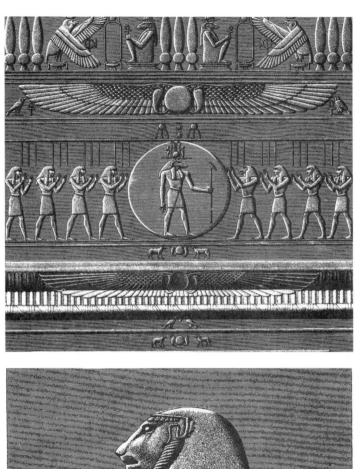

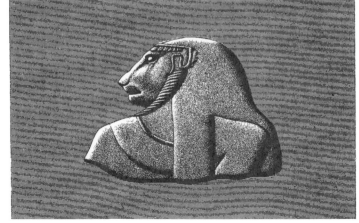

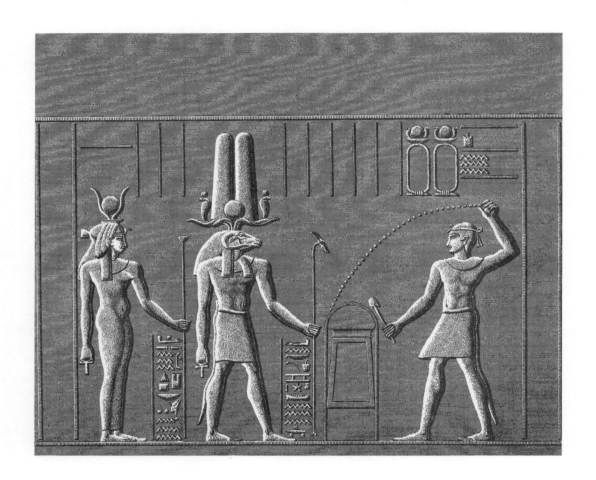

90

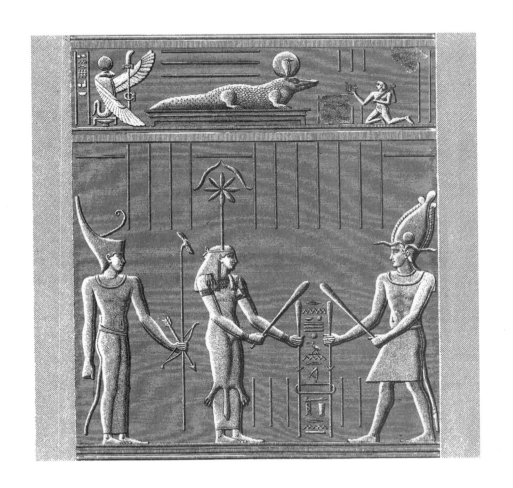

91

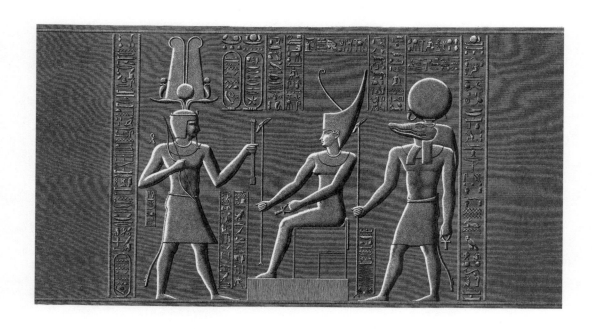

93:
Colossus. Thebes.
Colosse. Thèbes.
Koloss. Thebes.
Colosso. Tebas.
Колосс. Фивы.

Description de l'Égypte, Paris, 1809.

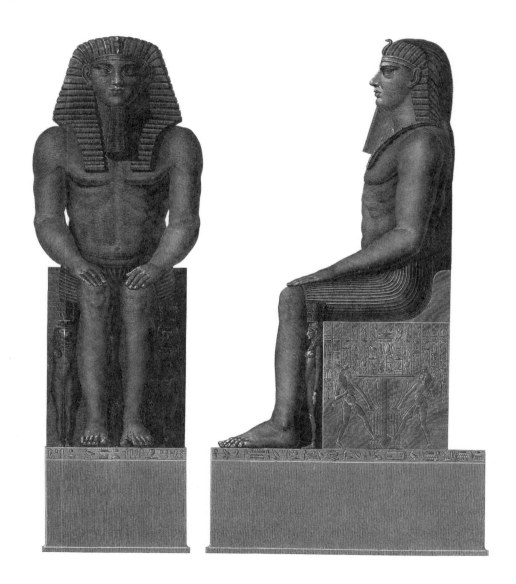

93

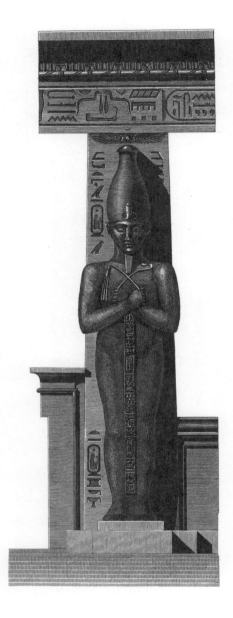

94:

Caryatid shaped pillar, Osymandias'
tomb. Thebes.

Pilier-caryatide, tombeau d'Osymandias.
Thèbes.

Säulenfigur, Grab von Osymandias.
Thebes.

Pilar-cariátide, sepulcro de Osymandias.
Tebas.

Колонна в форме кариатиды с
надгробия Осимандиаса. Фивы.

95-96:

Bas-reliefs. Thebes.

Bas-reliefs. Thèbes.

Flach erhabene Arbeit. Thebes.

Bajos relieves. Tebas.

Барельефы. Фивы.

Description de l'Égypte, Paris, 1809.

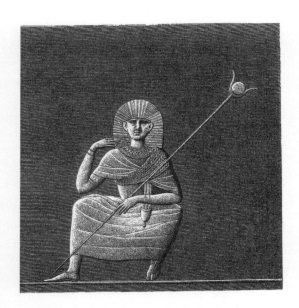

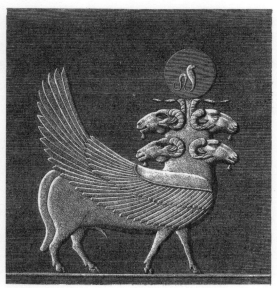

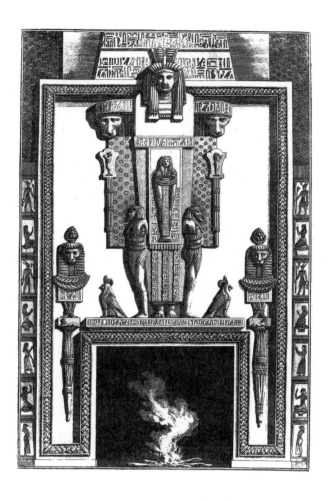

97-100: Piranesi. Egyptian style chimney, 1769.
Piranese. Cheminée à l'égyptienne, 1769.
Piranesi: Ägyptischer Kamin, 1769.
Piranese. Chimenea de estilo egipcio, 1769.
Пиранези. Камин в египетском стиле, 1769.

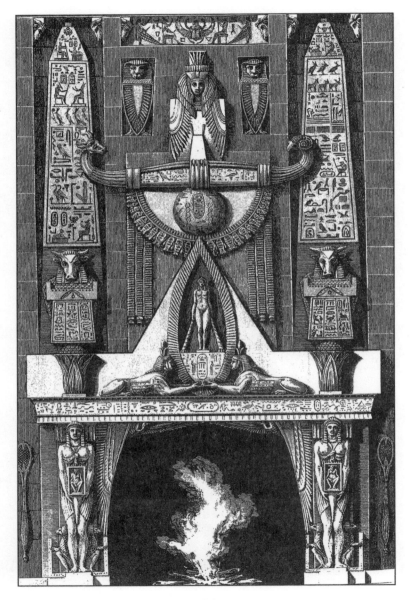

98

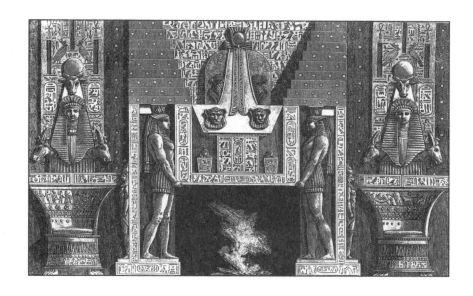

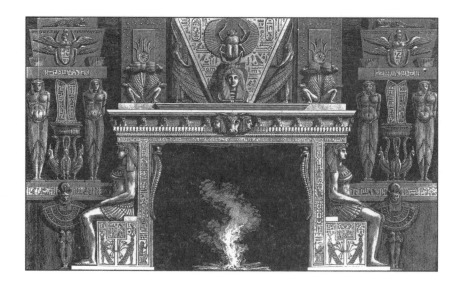

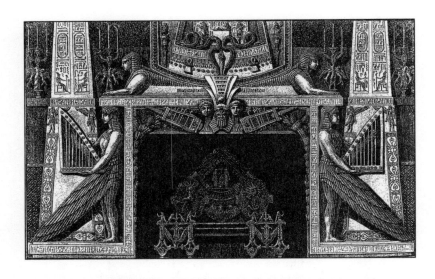

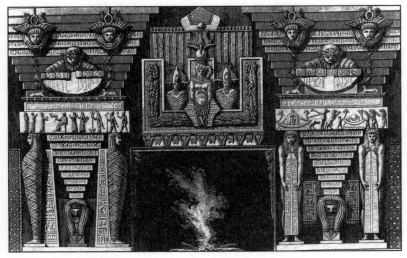

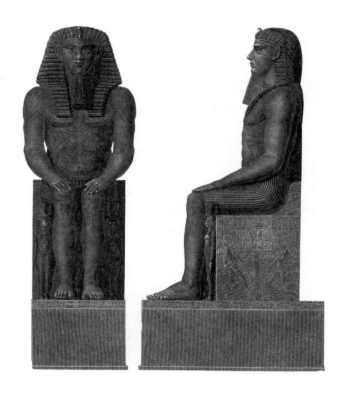

Colosseus, front and side views. Thebes.
Colosse de face et de profil. Thèbes.
Koloss, Vorderansicht und Seitenansicht. Thebes.
Coloso, frente y perfil. Tebas.
Колосс, вид спереди и сбоку. Фивы.

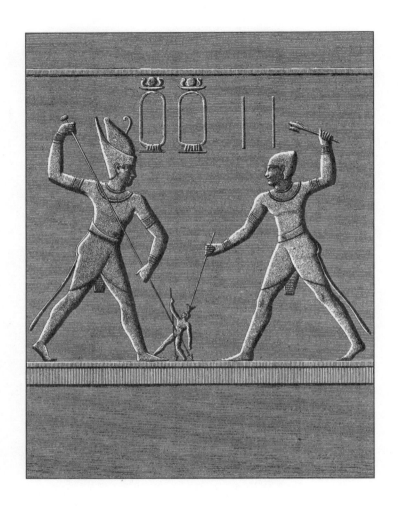

Isis temple: hypostyle rooom sculptures. Philæ.
Temple d'Isis : sculptures de la salle hypostyle. Philæ.
Tempel von Isis: Skulpturen im Säulensaal. Philae.
Templo de Isis: esculturas de la sala hipóstila. Philae.
Храм Исиды, скульптуры гипостильного зала. Philae.

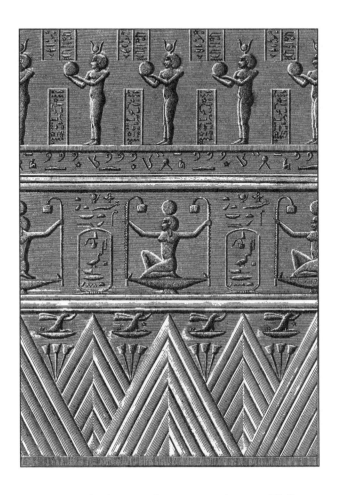

Isis temple: hypostyle room sculpture. Philæ.
Temple d'Isis : sculpture de la salle hypostyle. Philæ.
Tempel von Isis: ????. Philae.
Templo de Isis: escultura de la sala hipóstila. Philae.
Храм Исиды, скульптуры гипостильного зала. Philae.

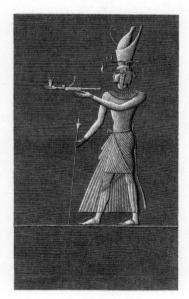

106-107: Hathor and Maat temple:bas-reliefs details. Thebes.
Temple d'Hathor et de Maat : détails de bas-reliefs. Thèbes.
Tempel von Hathor und Maat: Flach erhabene Arbeit, Einzelheiten. Thebes.
Templo de Hathor y Maat: detalles de bajos relieves. Tebas.
Храм Атора и Мата, фрагменты барельефов. Фивы.

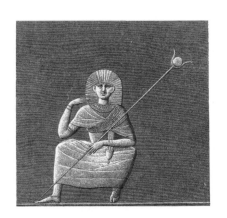

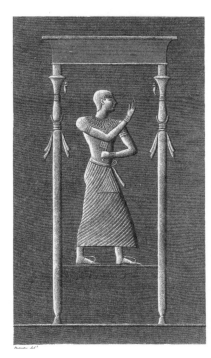

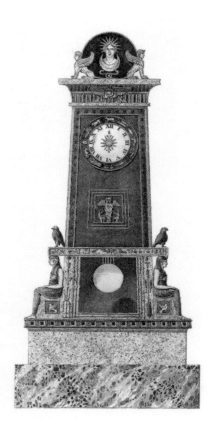

Percier and Fontaine. Egyptian style clock, Paris, 1801.
Percier et Fontaine. Pendule égyptienne, Paris, 1801.
Percier und Fontaine. Ägyptische Wanduhr, Paris, 1801.
Percier y Fontaine. Péndola de estilo egipcio, Paris, 1801.
Персье и Фонтен. Часы в египетском стиле. Париж, 1801.

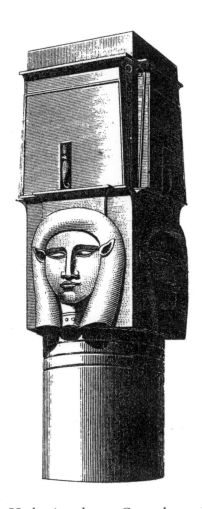

Hathoric column. Contralatopolis.
Colonne hathorique. Contralatopolis.
Kolonne mit Hathorfiguren. Contralatopolis.
Columna con figura de Hathor. Contralatopolis.
Колонна с изображением Атора. Контралатополис.

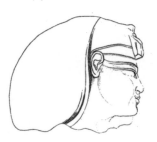

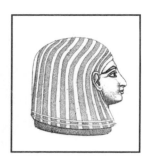

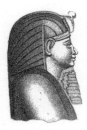

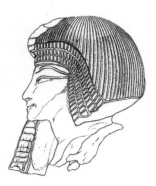

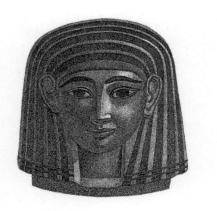

Royal hairstyles. Thebes.
Coiffures royales. Thèbes.
Peinados real. Tebas.
Königliche Frisuren. Thebes.
Прически царских особ. Фивы.

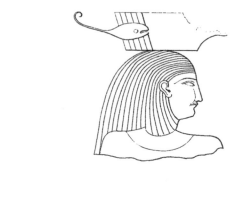

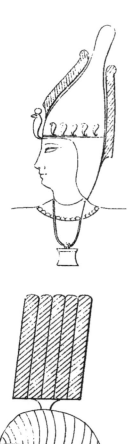

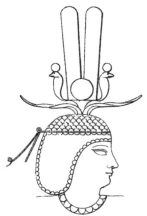

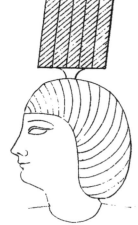

Symbolic hairstyles. Philae.
Coiffures symboliques. Philæ.
Symbolik Frisuren. Philae.
Peinados simbólicos. Philae.
Символические прически. Philae.

 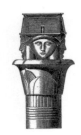

Capitals. Philae.
Chapiteaux. Philae.
Kapitelle. Philae.
Capiteles. Philae.
Капители колонн.
Philae.

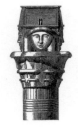 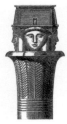 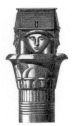

*Description de
l'Égypte,* Paris, 1809.

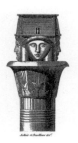 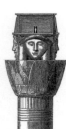 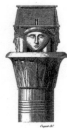

112

Animals
Animaux
Tiere
Animales
Животные

Tomb mural. Thebes.

Peinture murale d'une tombe. Thèbes.

Grabfresken. Thebes.

Pintura mural de un sepulcro. Tebas.

Настенные росписи гробницы. Фивы.

Tomb murals. **Left:** Thebes. **Right:** Tell el Amarna.

Peintures murales relevées dans des tombes. **À gauche:** Thèbes. **À droite:** Tell el Amarna.

Pinturas murales de tombas. **Izquierda:** Tebas. **Derecha:** Tell el Amarna.

Grabfresken. **Links:** Thebes. **Rechts:** Tell el Amarna.

Настенные росписи гробницы. Слева: Фивы. Справа: Тель эль Амарна.

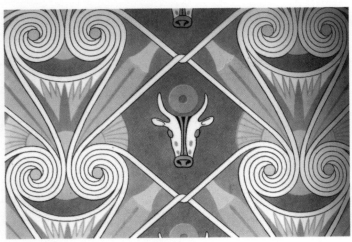

116

116-123:
Tomb murals. Thebes.
Peintures murales relevées dans des
tombes. Thèbes.
Grabfresken. Thebes.
Pinturas de sepulcros. Tebas.
Настенные росписи гробницы.
Фивы.

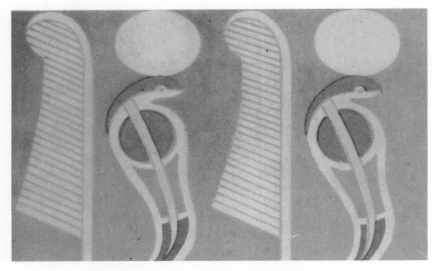

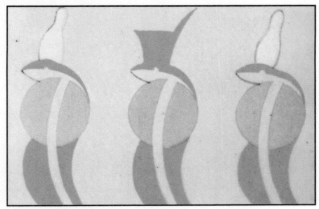

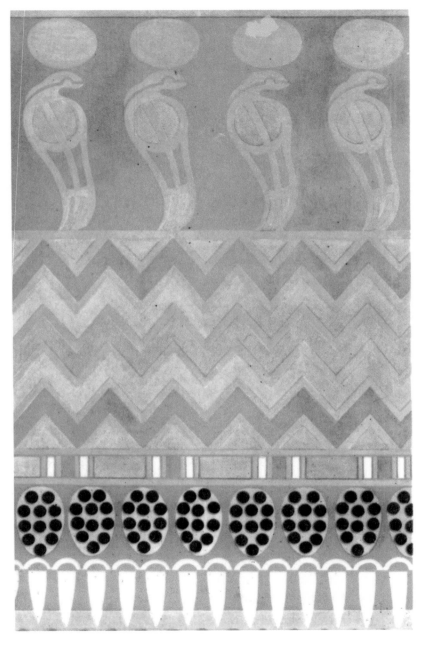

119

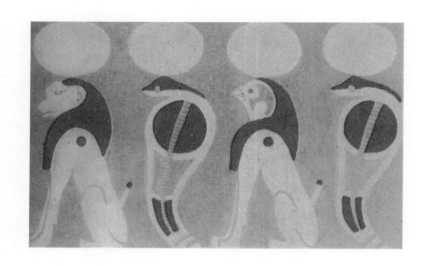

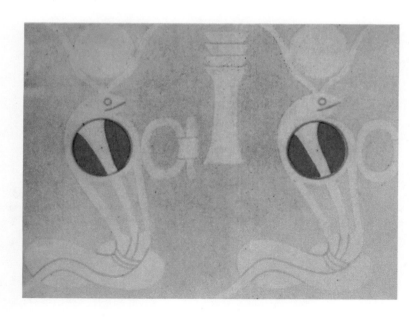

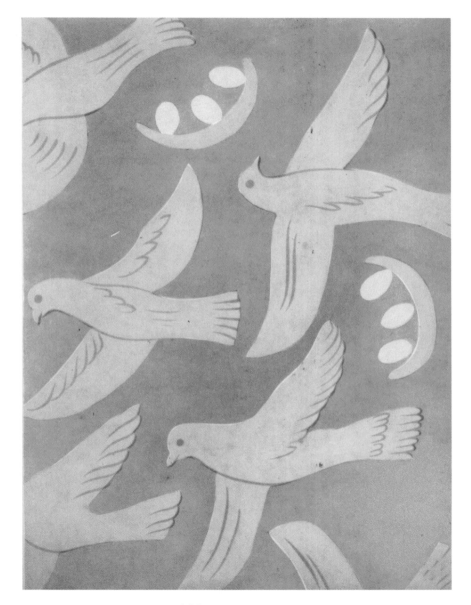

121

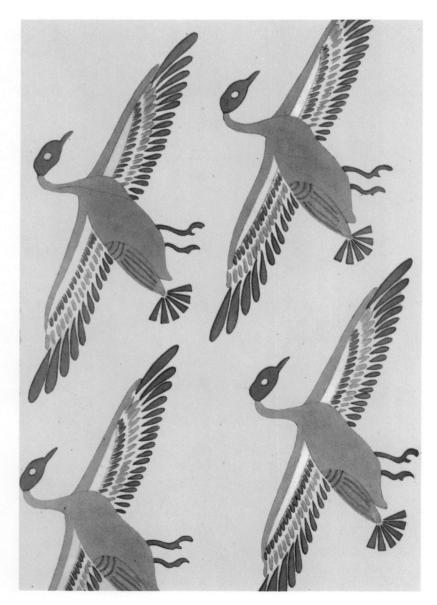

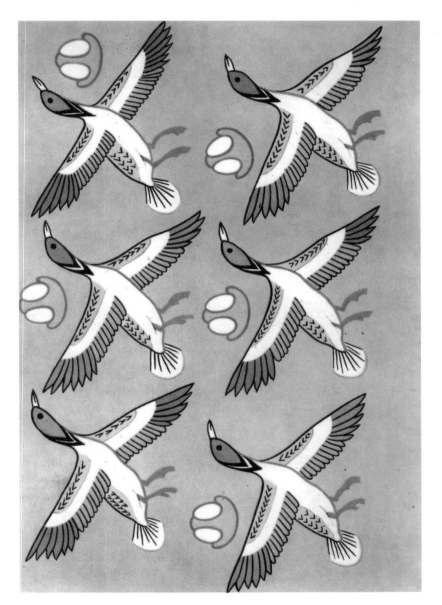

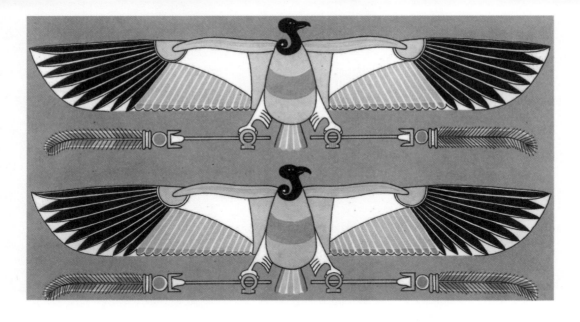

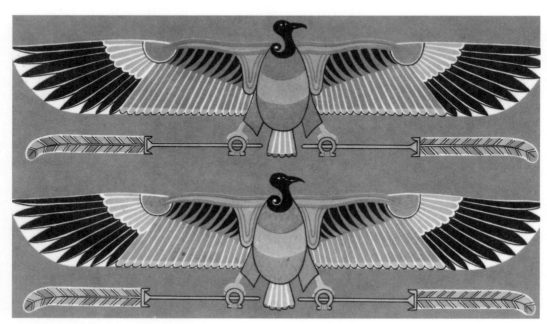

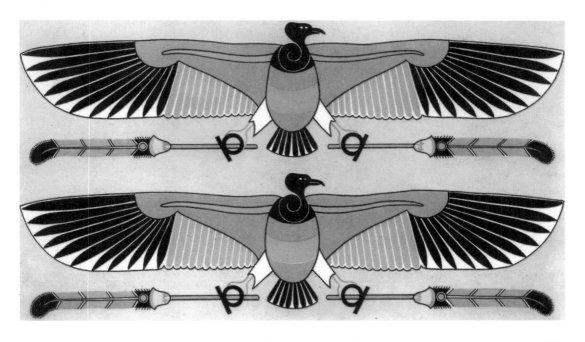

124:
Tomb murals. Philae.
Peintures murales de tombes. Philae.
Grabfresken. Philae.
Pinturas murales de sepulcros. Philae.
Настенные росписи гробницы. Philae.

125:
Tomb murals. Saqqara.
Peintures murales de tombes. Saqqara.
Grabfresken. Saqqara.
Pinturas murales de sepulcros. Saqqara.
Настенные росписи гробницы.
Саккара.

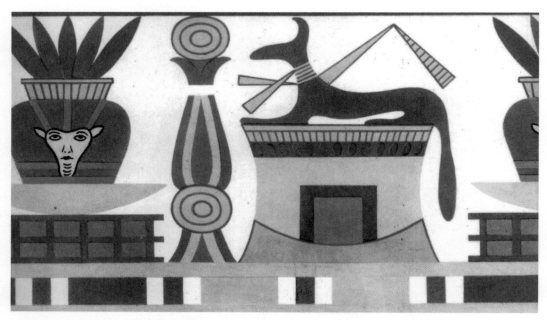

126:
Tomb murals. Thebes.
Peintures murales de tombes. Thèbes.
Grabfresken. Thebes.
Pinturas murales de sepulcros. Tebas.
Настенные росписи гробницы. Фивы.

127:
Sparrowhawk. Thoth's symbol.
Épervier, emblème de Thoth.
Sperber, Emblem von Thoth.
Gavilán, símbolo de Thoth.
Ястреб-перепелятник, символ Тота.

Champollion, *Panthéon égyptien,* Paris, 1823.

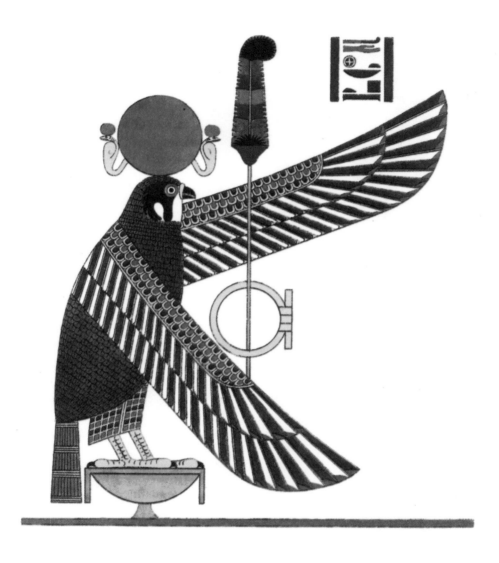

Agathodœmon snake,
Amon-Cnouphis' symbol.
Serpent Agathodœmon,
emblème d'Amon-
Cnouphis.
Schlange Agathodmon,
Emblem von Amon-
Cnouphis.
Serpiente Agathodœmon,
símbolo de Amon-
Cnouphis.
Змея Агатодемон, символ
Амона-Кнуфиса.

Champollion, *Panthéon
égyptien,* Paris, 1823.

Left: Ibis, Thoth's symbol. **Top, right:** Uræus
snake. **Bottom, right:** Scarab.
À gauche: Ibis, emblème de Thoth. **En haut, à
droite:** Serpent Uræus. **En bas, à droite:** Scarabée.
Links: Ibis, Emblem von Thoth. **Oben rechts:**
Uræus-Schlange. **Unten rechts:** Skarabäus.
Izquierda: Ibis, símbolo de Thoth. **Arriba,
derecha:** Serpiente Uræus. **Abajo, derecha:**
escarabajo.
Слева: Ибис, символ Тота. Справа наверху:
Змея Уреус. Внизу справа: Жук-скарабей.

Champollion, *Panthéon égyptien,* Paris, 1823.

130

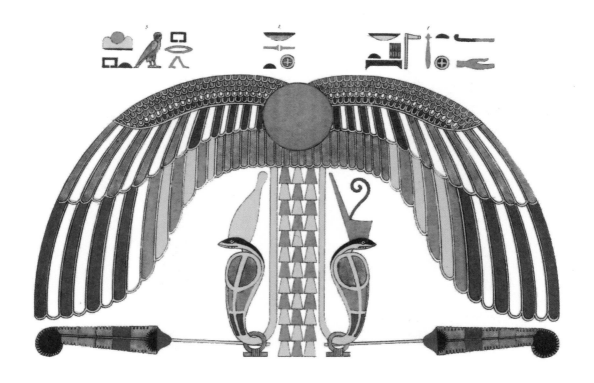

132:
Sparrowhawk headed moon god.
Dieu-lune à tête d'épervier.
Mond-Gott an Sperberkopf.
Dios-luna con cabeza de gavilán.
Бог Луны с головой ястреба-
перепелятника.

131:
Thoth-Trismégist's symbol.
Emblème de Thoth-Trismégiste.
Emblem von Thoth-Trismégiste.
Símbolo de Thoth-Trismegiste.
Символ Тота-Трисмегиста.

Champollion, *Panthéon égyptien,* Paris, 1823.

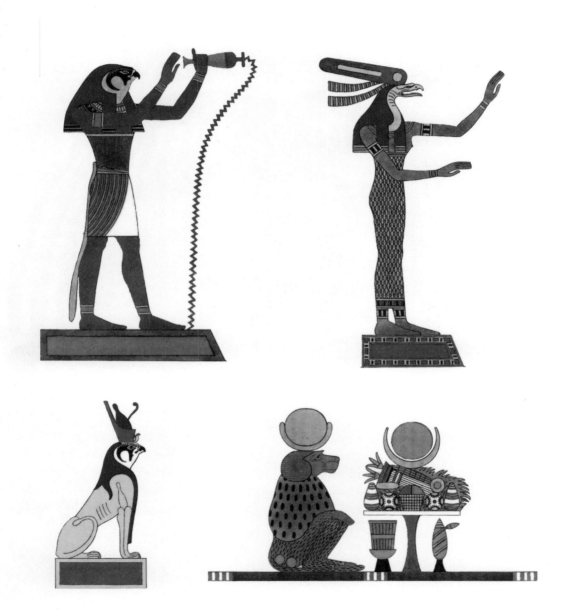

134

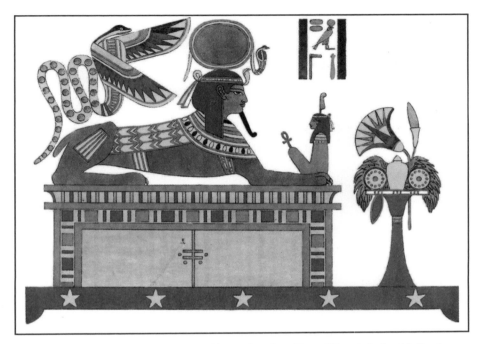

134:

Top, left: Thoth-Trismégist. **Top, right:** Ilithya. **Bottom, left:** Aroueris. **Bottom, right:** Dog-faced baboon, moon god symbol.

En haut, à gauche: Thoth-Trismégiste. **En haut, à droite:** Ilithya. **En bas, à gauche:** Aroueris. **En bas, à droite:** Cynocéphale, emblème du dieu-lune.

Oben, links: Thoth-Trismegiste. **Oben, rechts:** Ilithya. **Unten, Links:** Aroueris. **Unten, rechts:** Hundskopfaffe, Emblem des Mond-Gottes.

Arriba, izquierda: Thoth-Trismégiste. **Arriba, derecha:** Ilithyia. **Abajo, izquierda:** Aroueris.

Abajo, derecha: Cinocéfalo, símbolo del dios-luna.

Наверху слева: Тот-Трисмегист. Наверху справа: Элетия. Внизу слева: Гор-старший. Внизу справа: Обезьяна-бабуин с мордой собаки, символ бога Луны.

135:

Sphinx du dieu Phre.

Sphinx des Gottes Phre.

Сфинкс бога Фре.

Champollion, *Panthéon égyptien,* Paris, 1823.

135

136:
Neith.
Нейт.

137:
Phre.
Фре.

138:
Mnevis.
Мневис.

139:
Ram, Amon-Ra's
symbol.
Bélier, emblème
d'Amon-Ra.
Widder, Emblem von
Amon-Ra.
Morueco, símbolo de
Amon-Ra.
Баран, символ
Амона-Ра.

Champollion,
Panthéon égyptien,
Paris, 1823.

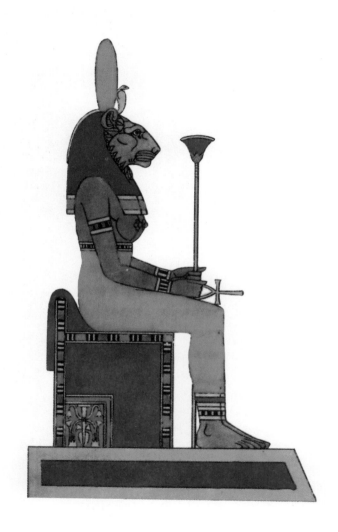

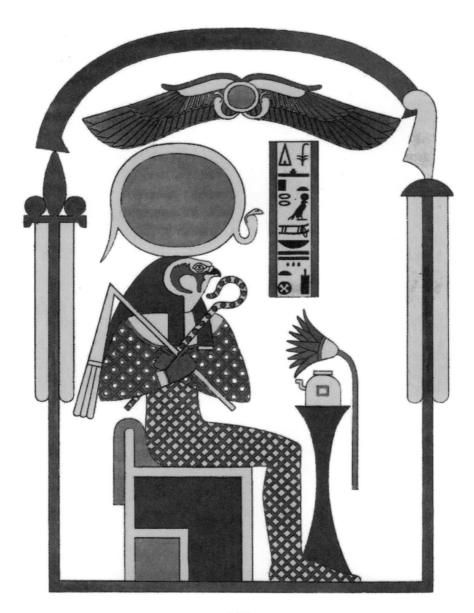

137

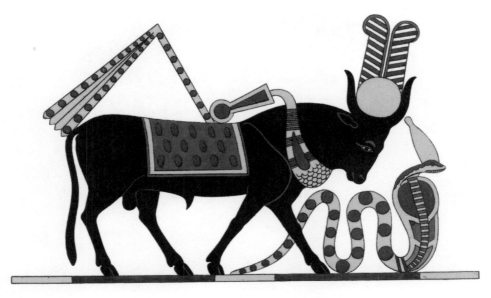

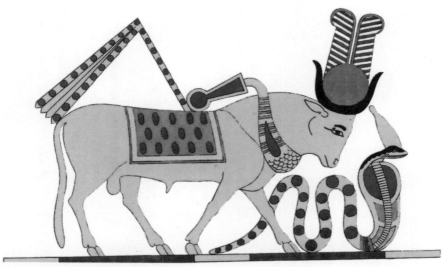

138

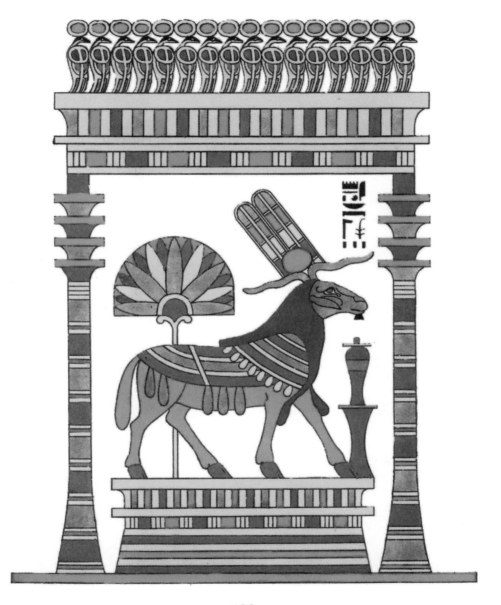

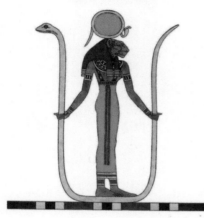

140:
Left: Neith. **Right:** Thoth.
À gauche: Néith. **À droite:** Thoth.
Links: Neith. **Rechts:** Thoth.
Izquierda: Neith. **Derecha:** Thoth.
Слева: Нейт. Справа: Тот.

Champollion, *Panthéon égyptien,*
Paris, 1823.

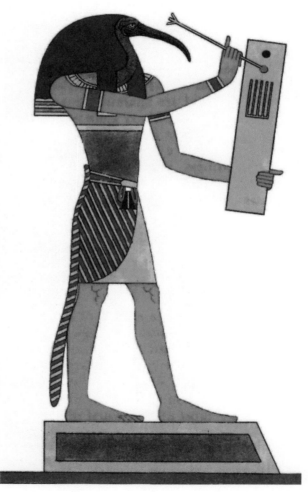

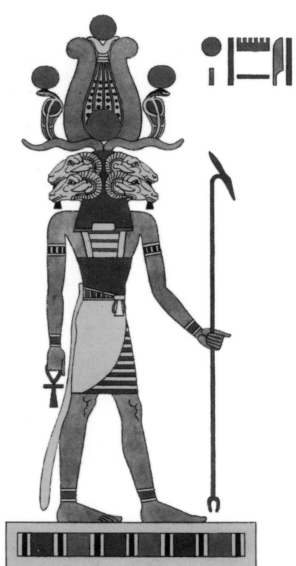

141:
Amon-Ra.
Амон-Ра.

142:
Cnouphis-Nilus.
Кнуфис-Нилус.

143:
Sacred ram.
Bélier sacré.
Heiliger Widder.
Morueco sagrado.
Священный баран.

Champollion, *Panthéon égyptien,*
Paris, 1823.

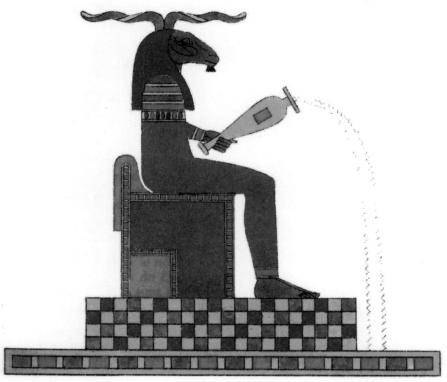

142

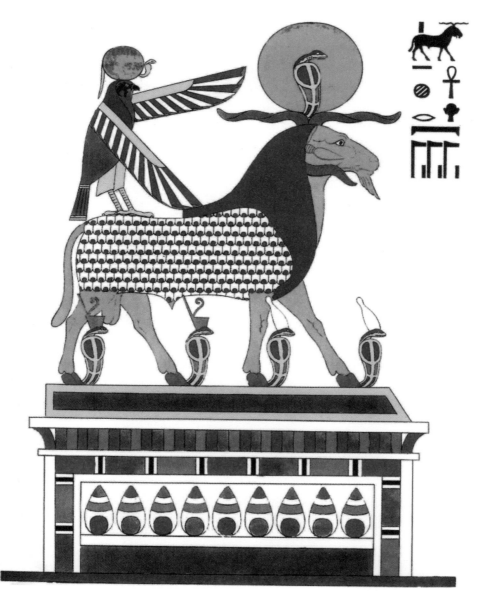

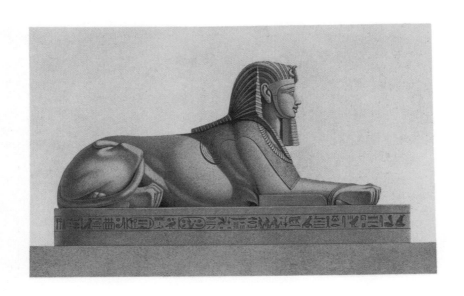

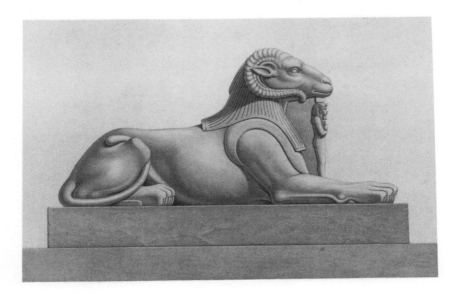

144

144:
Top: Androcephalus sphinx, Thebes. **Bottom:** Ram headed sphinx, Karnak.
Haut: Sphinx androcéphale, Thèbes. **Bas:** Sphinx à tête de bélier, Karnak.
Oben: Androcephalus sphinx, Thebes. **Unten:** Sphinx mit Widderkopf, Karnak.
Arriba: esfinge con una cabeza de hombre. Tebas. **Abajo:** Esfinge con una cabeza de morueco. Karnak.
Наверху: Сфинкс-андроцефал. Фивы. Внизу: Сфинкс с головой барана. Карнак.

Prisse d'Avennes, *L'Art égyptien,* Paris, 1879.

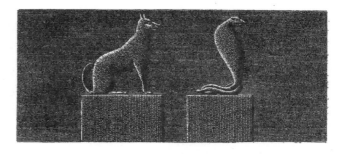

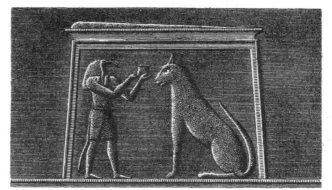

145-146:
Hermonthis temple bas-reliefs.
Bas-reliefs du temple d'Hermonthis.
Flach erhabene Arbeit des Tempels von Hermonthis.
Bajos relieves del templo de Hermonthis.
Храм Гермонтиса, барельефы.

Description de l'Égypte, Paris, 1809.

145

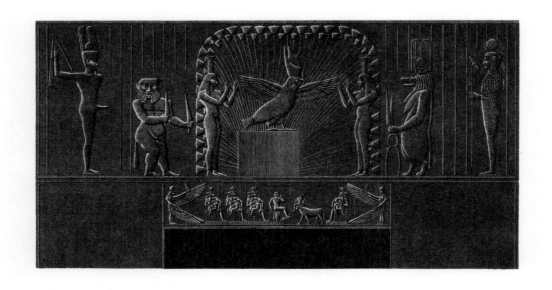

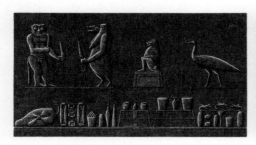

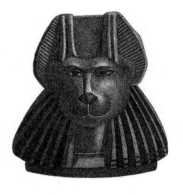
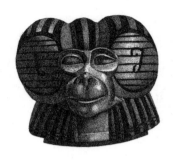

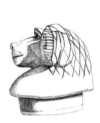
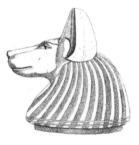

Vases covers.
Couvercles de vases.
Vasendeckel.
Tapadera de vasos.
Крышки ваз.

Description de l'Égypte, Paris, 1809.

147

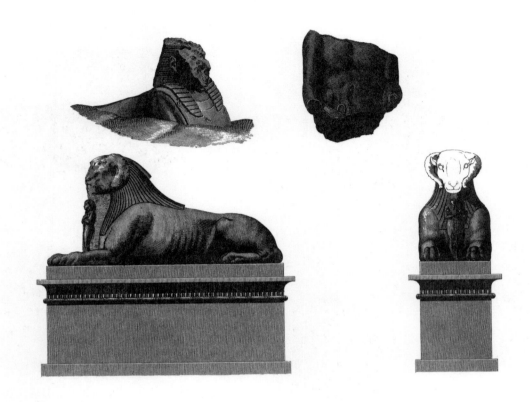

148-150:
Sphinx. Karnak.
Esfinge. Karnak.
Сфинкс. Карнак.

Description de l'Égypte, Paris, 1809.

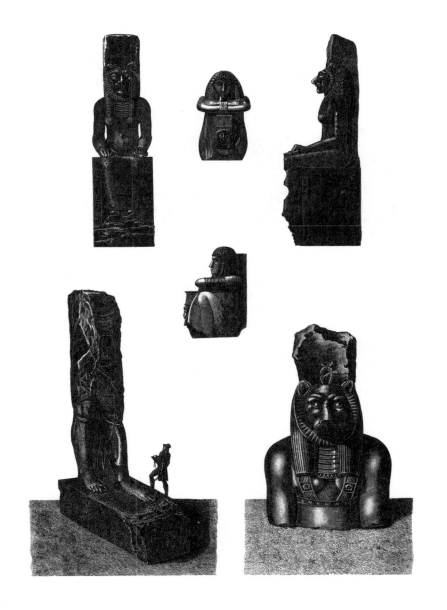

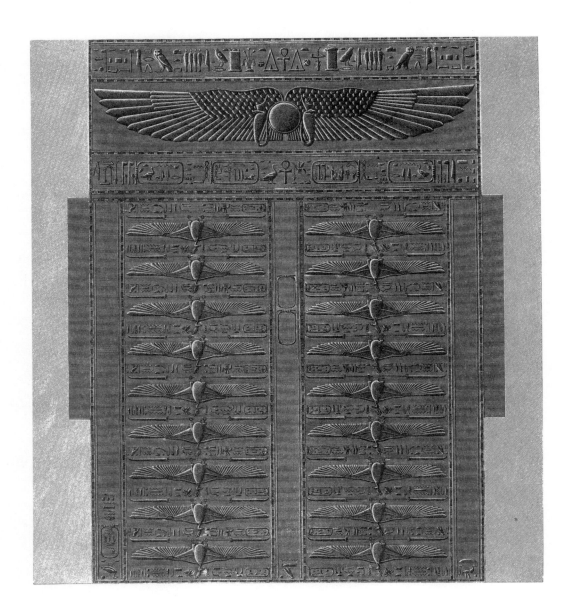

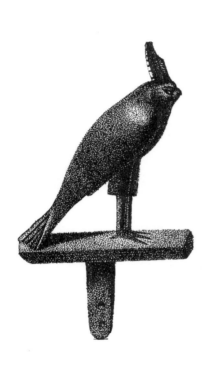

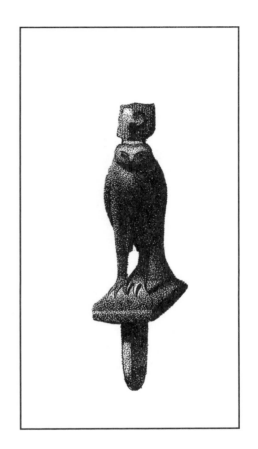

155-157:
Bronze figures.
Figures en bronze.
Bronzefiguren.
Estatuitas de bronce.
Бронзовые фигуры.

Description de l'Égypte, Paris, 1809.

155

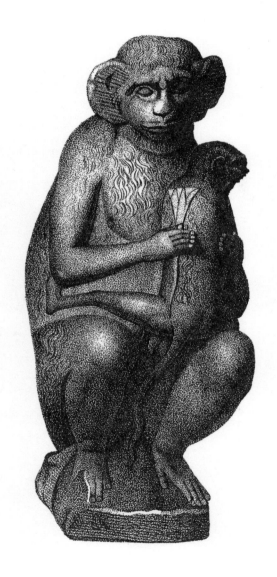

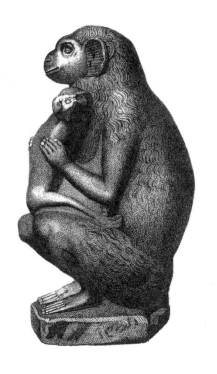
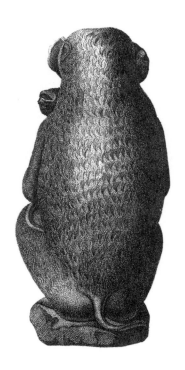

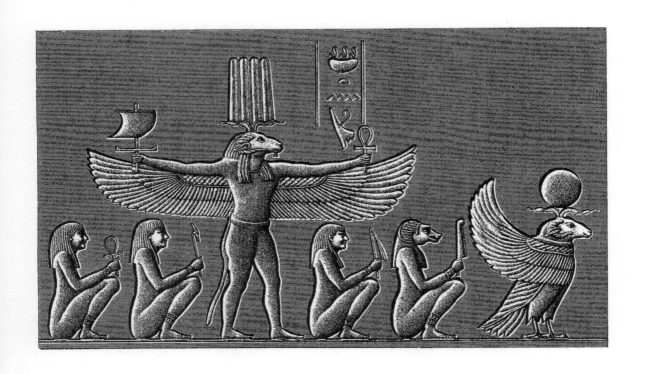

158-159:
Bas-reliefs. Denderah.
Flach erhabene Arbeit. Denderah.
Bajos relieves. Denderah.
Барельефы, Дендера.

Description de l'Égypte, Paris, 1809.

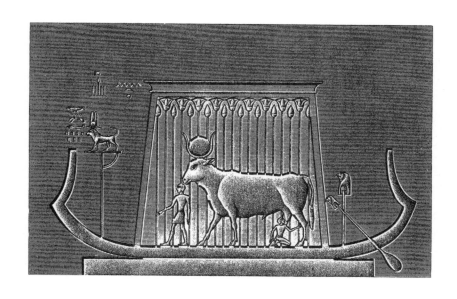

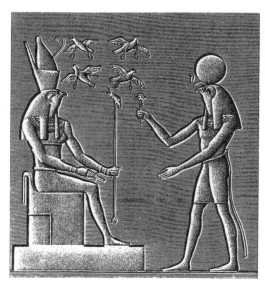

159

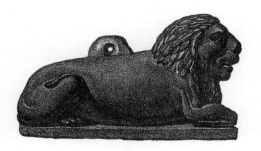

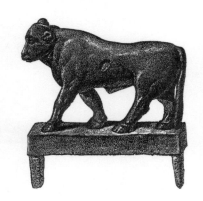

Bronze, stone and terracotta figures.
Figures en bronze, pierre et terre cuite.
Figuren in Bronze, Stein und Tonerde.
Estatuitas de bronce, piedra y terracota.
Фигурки из бронзы, камня и
терракоты.

Description de l'Égypte, Paris, 1809.

Geometric patterns
Motifs géométriques
Geometrische Gegenstände
Motivos geométricos
Геометрические узоры

162-163:
Friezes. Thebes.
Frises. Thèbes.
Fries. Thebes.
Frisos. Tebas.
Фризы. Фивы.

Tunic detail. Saqqara.
Détail d'une tunique. Saqqara.
Einzelheit eines Rocks. Saqqara.
Detalle de una túnica.
Фрагмент туники. Саккара.

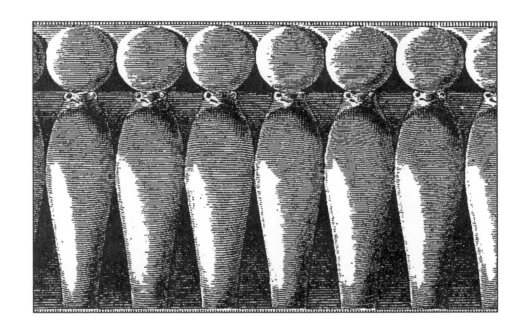

Soukhos and Haroeris temple: cobras frieze. Kum Umbu.
Temple de Soukhos et Haroéris : frise de cobras. Kum Umbu.
Tempel von soukhos und Haroeris: Kobra, Fries. Kum Umbu.
Templo de Soukhos y Haroeris: friso de cobras. Kum Umbu.
Храм Сухоса и Гора-старшего, фриз с изображением кобр. Кум Умбу.

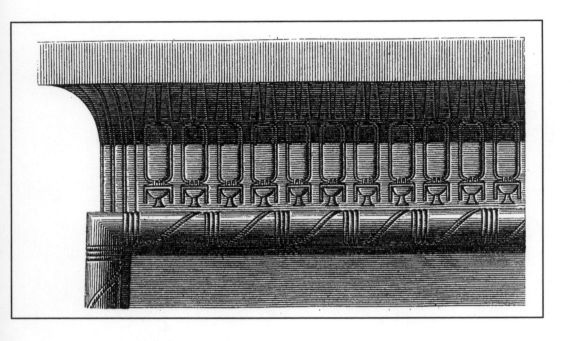

Thot temple: detail from the hypostyle room. Ashmunayn.
Temple de Thot : détail de la salle hypostyle. Ashmunayn.
Tempel von Thoth: Säulensaal, Einzelheiten. Ashmunayn.
Templo de Thoth: detalles de la sala hipóstila.
Храм Тота, фрагмент гипостильного зала. Ашмунаин.

Bas-reliefs details. Bani Hasan.
Détails de bas-reliefs. Bani
Hasan.
Flach erhabene Arbeit,
Einzelheiten. Bani Hasan.
Detalles de bajos relieves. Bani
Hasan.
Фрагменты барельефов. Бани
Хасан.

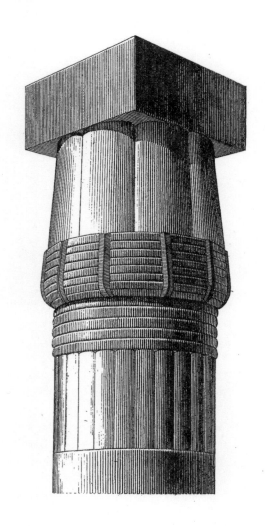

168-169: Sethi I temple: lotus shaped capital. Thebes.
Temple de Sethi Ier : chapiteau en forme de lotus. Thèbes.
Tempel von Sethi I: Kapitell in Lotus-Form. Thebes.
Templo de Sethi I: capitel en forma de loto. Tebas.
Храм Сетха I, капитель в форме лотоса. Фивы.

168

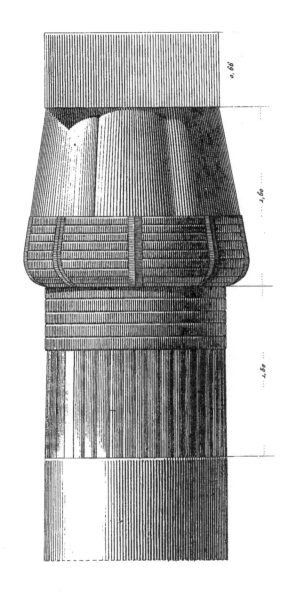

172

173

175:

Top: Tomb murals. Thebes.
Bottom: Temple murals. Philæ.
Haut: Peintures murales relevées dans des tombes. Thèbes. **Bas:** Peintures murales relevées dans un temple. Philae.
Oben: Grabfresken. Thebes. **Unten:** Tempelfresken. Philae.

Arriba: Pinturas murales de sepulcros. Tebas. **Abajo:** Pinturas murales de templos. Philae.
Наверху: Настенные росписи гробницы. Фивы. Внизу: Настенные росписи храма. Фивы.

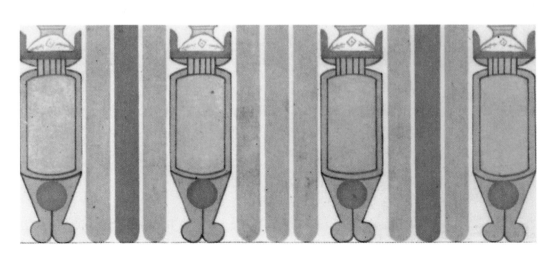

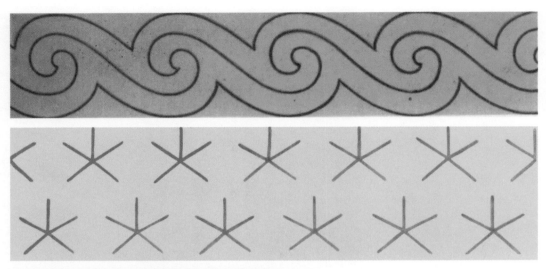

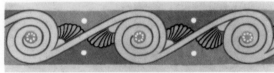

175-181:
Tomb murals. Thebes.
Peintures murales de tombes. Thèbes.
Grabfresken. Thebes.
Pinturas murales de sepulcros. Tebas.
Настенные росписи гробницы.
Фивы.

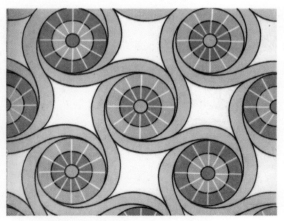

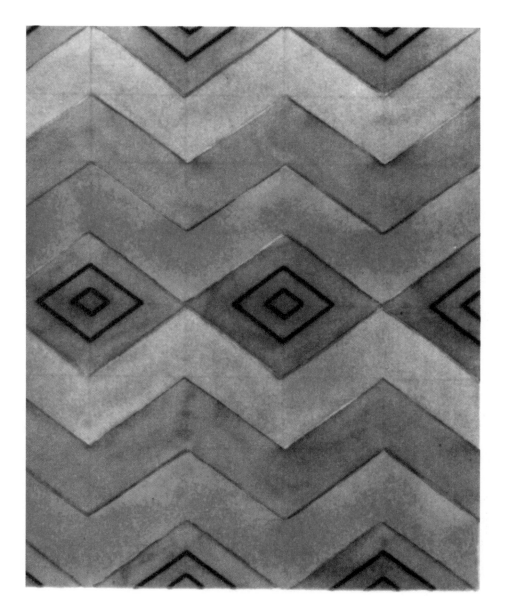

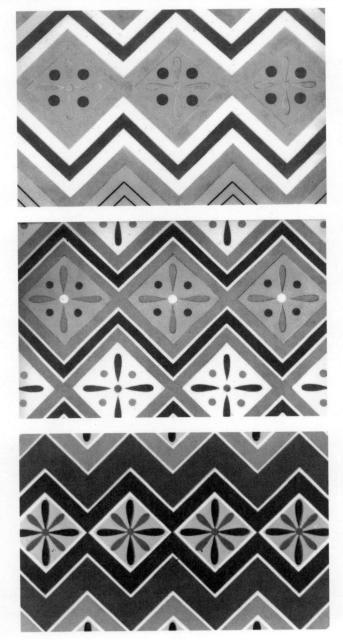

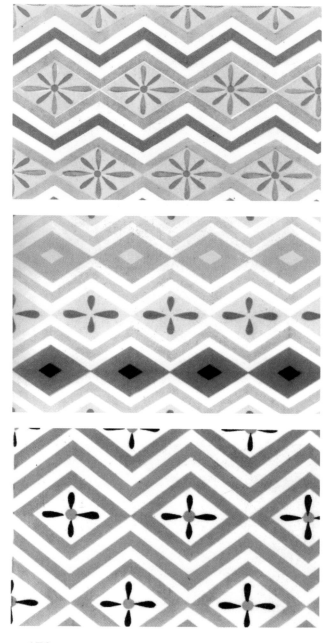

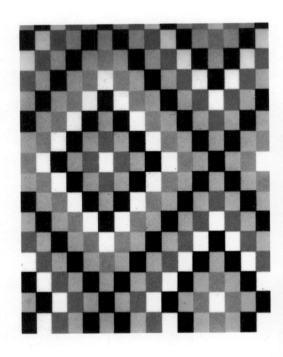

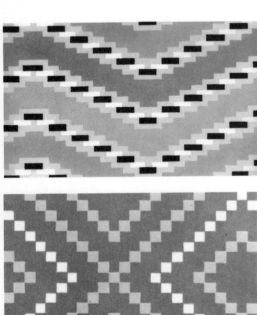

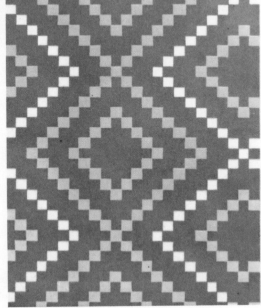

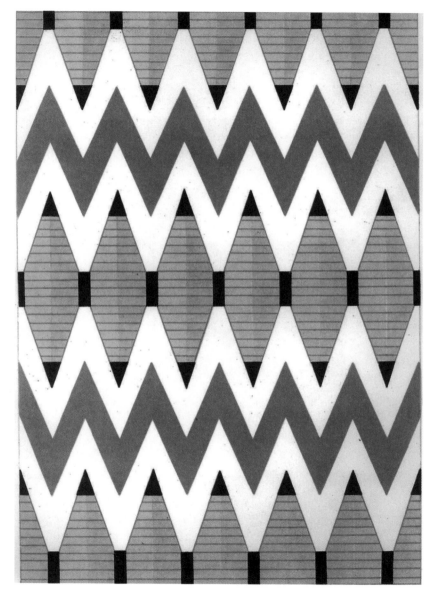

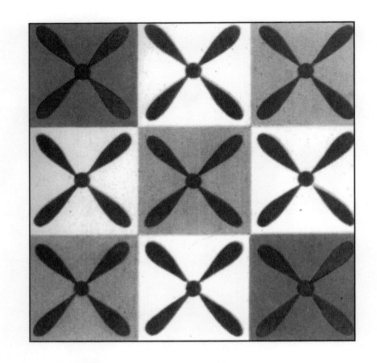

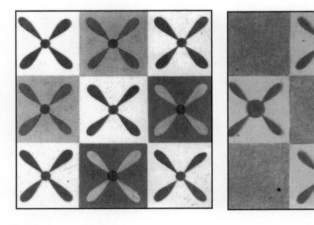

182:
Top: Tomb murals. Beni Hasan. **Bottom:** Tomb murals. Thebes.
Haut: Peintures murales de tombes. Beni Hasan.
Bas: Peintures murales de tombes. Thèbes.
Oben: Grabfresken. Beni Hasan. **Unten:** Grabfresken. Thebes.
Arriba: Pinturas murales de sepulcros. Beni Hasan
Abajo: Pinturas murales de sepulcros. Tebas.
Наверху: Настенные росписи гробницы. Бани Хасан. Внизу: Настенные росписи гробницы. Фивы.

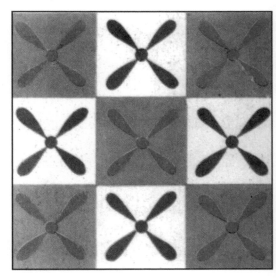

183:
Tomb murals. Thebes.
Peintures murales de tombes. Thèbes.
Grabfresken. Thebes.
Pinturas murales de sepulcros. Tebas.
Настенные росписи гробницы. Фивы.

184:
Tomb mural. Saqqara.
Peinture de tombe. Saqqara.
Grabfreske. Saqqara.
Настенные росписи гробницы. Саккара.

185:
Tomb mural. Tell el Amarna.
Peinture murale de tombe. Tell el Amarna.
Grabfreske. Tell el Amarna.
Pintura mural de uno sepulcro. Tell el Amarna.
Настенные росписи гробницы. Тель Эль Амарна.

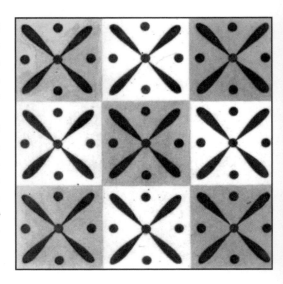

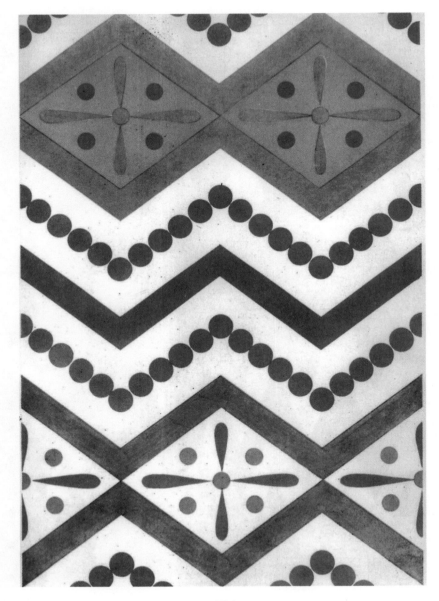

184

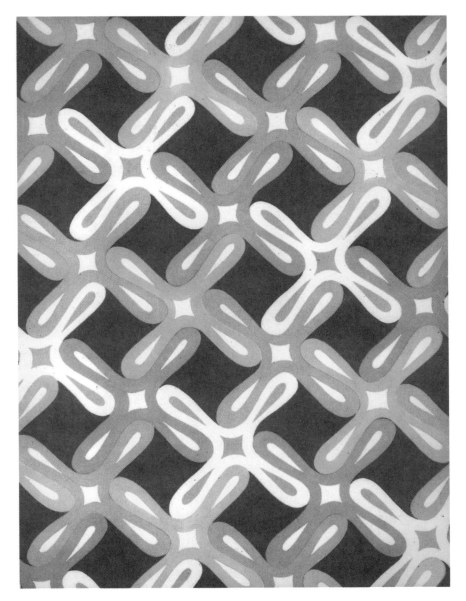

186-189:
Tomb murals. Thebes.
Peintures murales de tombes. Thèbes.
Grabfresken. Thebes.
Pinturas murales de sepulcros. Tebas.
Настенные росписи гробницы. Фивы.

189

190:
Enamelled terracotta vase, detail.
Vase en terre cuite émaillée, détail.
Vase in emailierter Tonerde, Einzelheite.
Vaso de terracota esmaltada, detalle.
Ваза из глазурованной терракоты, фрагмент.

191-197:
Tomb murals. Thebes.
Peintures murales de tombes. Thèbes.
Grabfresken. Thebes.
Pinturas murales de sepulcros. Tebas.
Настенные росписи гробницы. Фивы.

191

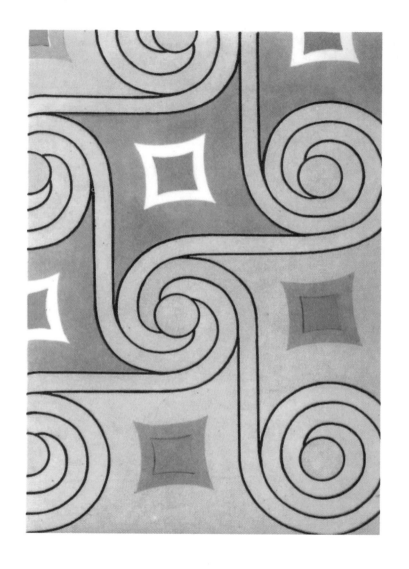

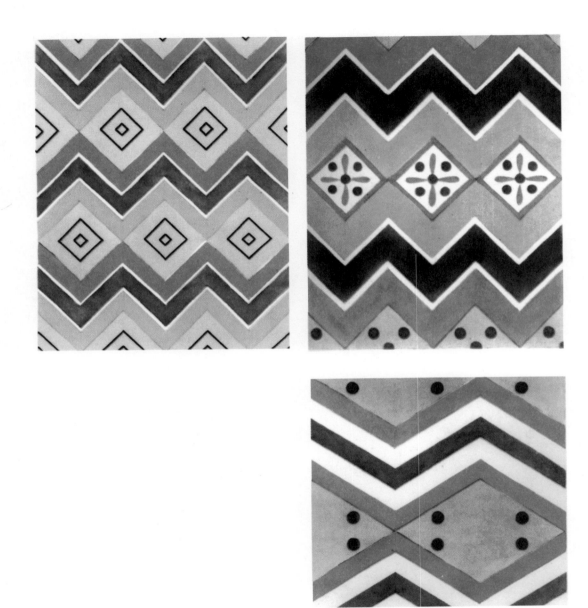

196

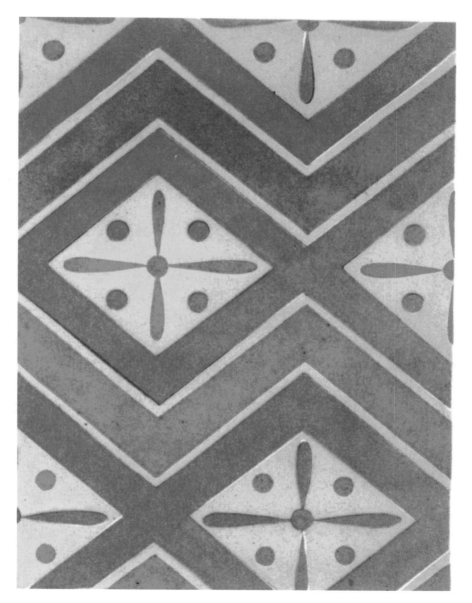

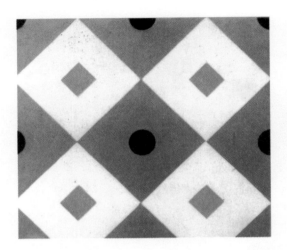

199-201:
Tomb murals. Thebes.
Peintures murales de tombes. Thèbes.
Grabfresken. Thebes.
Pinturas murales de sepulcros. Tebas.
Настенные росписи гробницы. Фивы.

198:
Tomb murals. **Left:** Zawiet el Majetin.
Right: Thebes.
Peintures murales de tombes. **À gauche:**
Zawiet el Majetin. **À droite:** Thèbes.
Grabfresken. **Links:** Zawiet el Majetin.
Rechts: Thebes.
Pinturas murales de sepulcros.
Izquierda: Zawiet el Majetin. **Derecha:**
Tebas.
Настенные росписи гробницы.
Слева: Завьет эль Майетин.
Справа: Фивы.

199-201:
Tomb murals. Thebes.
Peintures murales de tombes. Thèbes.
Grabfresken. Thebes.
Pinturas murales de sepulcros. Tebas.
Настенные росписи гробницы. Фивы.

201

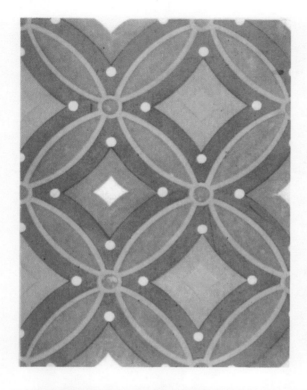

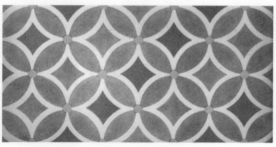

202:
Top: Tomb murals. Thebes. **Bottom:** Coffin.
Haut: Peintures murales de tombes. Thèbes. **Bas:** Cercueil.
Oben: Grabfresken. Thebes. **Unten:** Sarg.
Arriba: Pinturas murales de sepulcros. Tebas. **Abajo:** Ataúd.
Наверху: Настенные росписи гробницы. Фивы.
Внизу: Гроб.

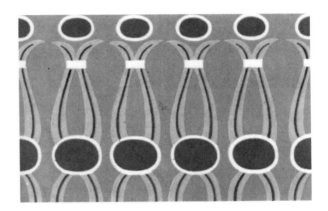

203-205:
Tomb murals. Thebes.
Peintures murales de tombes.
Thèbes.
Grabfresken. Thebes.
Pinturas murales de sepulcros.
Tebas.
Настенные росписи гробницы.
Фивы.

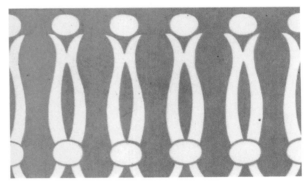

203

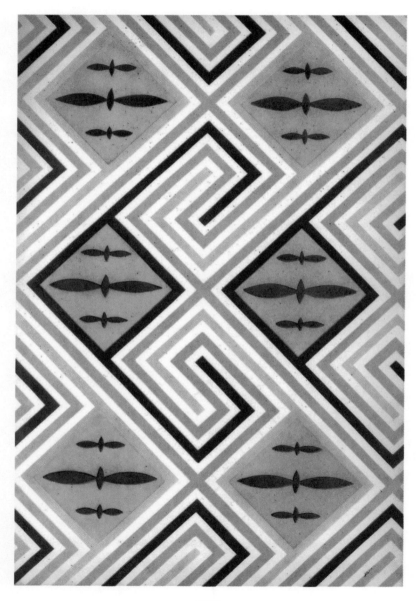

204

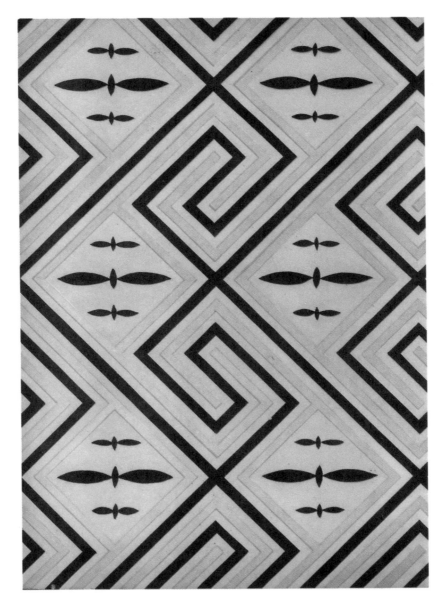

205

Achevé d'imprimer
en Slovaquie
en janvier 2005

Dépôt légal 1e trimestre 2005